IMPRESSIONISTS' SEASONS

We are infinitely grateful to some painters for achieving with their palettes what the poets of their time have been able to render with a totally new emphasis: the intense heat of the summer sky; the poplar leaves turned into gold coins by the first hoarfrosts; the long shadows cast by the trees in winter on the fields; the Seine at Bougival; or the sea on the coast, quivering in the morning breeze; children rolling on lawns dotted with little flowers. They are like small fragments of universal life, and the rapid and colourful, subtle and charming things that are there reflected have every right to be cared about and celebrated.

ERNEST D'HERVILLY, *Le Rappell*

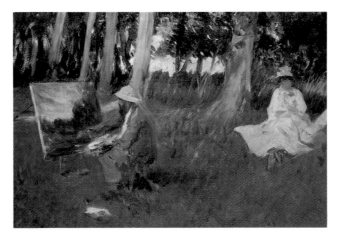

IMPRESSIONISTS'
SEASONS

EDITED BY RUSSELL ASH

CollinsPublishersSanFrancisco

A Division of HarperCollins*Publishers*

First published in USA in 1995 by
Collins Publishers San Francisco
1160 Battery Street
San Francisco CA 94111

First published in 1995 by
Pavilion Books Limited
26 Upper Ground
London SE1 9PD

Produced by Ash & Higton
Introduction and text selection © Russell Ash 1995
Designed by Bernard Higton
Editorial research by Vicki Rumball
Picture research by Mary-Jane Gibson

Picture credits on page 88

Library of Congress Cataloging-in-Publication Data

Impressionists' seasons / edited by Russell Ash
 p. cm.
 ISBN 0-00-225046-2
 1. Impressionism (Art)–France. 2. Painting, French.
 3. Painting. Modern–19th century–France. 4. Seasons in art.
 I. Ash, Russell.
 ND547.5.I4I52 1995
 759.4'09'034–dc20 95-1955

Printed and bound in Singapore

10 9 8 7 6 5 4 3 2 1

C O N T E N T S

INTRODUCTION

Before the advent of Impressionism, the four seasons of the year were traditionally depicted – if they were depicted at all – either symbolically or allegorically. Although a handful of precursors, such as Corot, Millet, and those Barbizon painters from whom the Impressionists themselves acknowledged their descent, sought to represent seasonal variations in their landscape paintings, it was the Impressionists, with their concern for painting in the open air, who were the first consistently to portray their subjects naturalistically and to attempt to capture the effects of changing weather and light through the different seasons.

In 1821, before any of the Impressionists were born, the British artist John Constable had advised: "That landscape painter who does not make his skies a very material point of his composition neglects to avail himself of one of his greatest aids... The sky is the source of light in nature and governs everything." The founders of Impressionism were instinctively aware of this advice, as the French art historian Elie Faure observed in his description of Claude Monet's technique:

> He distinguishes the summer sun from the winter sun and the spring sun from the autumn sun. The sun at dawn and the sun at twilight is never the same as the sun that shines for ten or fifteen hours running from sunrise to sunset. The artist watches it every minute rising, waxing and waning, he sees its unexpected eclipses and sudden changing course on the boundless surface of life whose features, timbre and accents change with every season, with every month and week, with the wind,

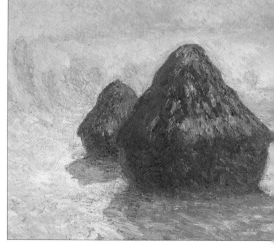

Claude Monet

Below: *Grainstacks (Snow effect; sunlight)* 1890–91.

Opposite: *Grainstacks (end of summer)* (detail) 1891

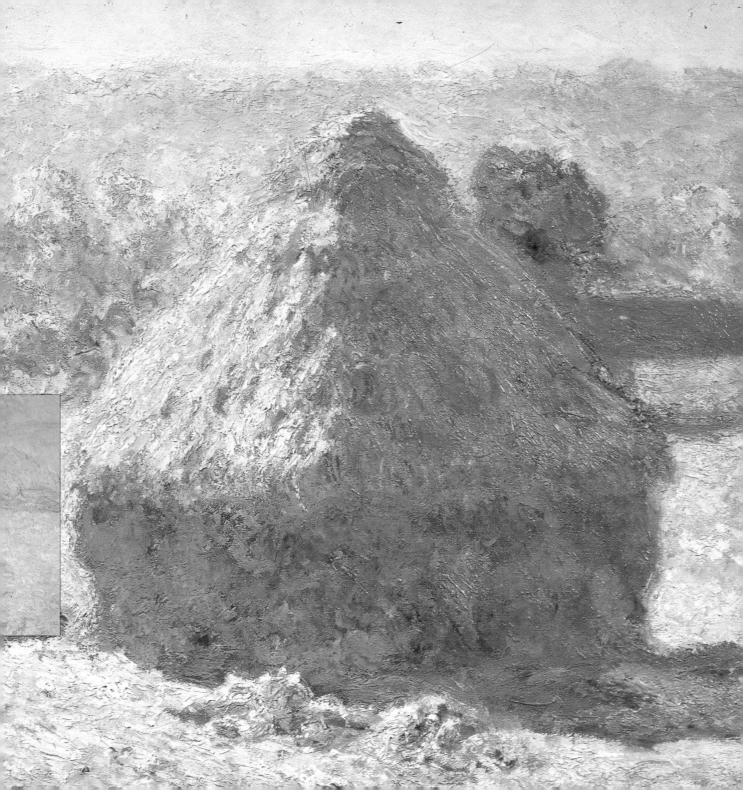

> the rain and the dust, with the snow and the frost. There are a hundred images of the same water...of the same trees, and they are similar to laughter and smiles, suffering and hope, anxiety and fear in the same human face; they change with the strong light or deep shadow that envelops them, or with all the hues which separate deep shadow from strong light.

Soon after the opening of the first Impressionist exhibition in 1874, the critic Philippe Burty explained to his readers in *La République Française* that: "The group is pursuing, with quite obvious individual variations, a common artistic goal: on a technical level, they are trying to capture the ample light of the open air; on the level of feeling they are attempting to convey the vividness of first sensations."

As Burty pointed out, while each of various members of the group was following this aspiration according to his own personal style, at this stage the central theme of them all was to communicate their interpretations of the rich variety of the French countryside as it metamorphosed through the seasons. The Impressionists were concerned to break with the traditions of their forebears and to work objectively, without sentimentality or romanticism, and in harmony with nature. Vincent van Gogh was the most vociferous in explaining his desire to maintain a rapport with the seasons, writing in a letter to his brother Theo:

> I was sick of the *boredom* of civilization. It *is* better, one *is* happier if one carries it out – literally though – one feels at least that one is really alive. And it is a good thing in winter to be deep in the snow, in the autumn deep in the yellow leaves, in summer among the ripe corn, in spring amid the grass; it is a good thing to be always with the mowers and the peasant girls, in summer with a big sky overhead, in winter by the fireside, and so to feel that it has been and always will be so.

The Impressionists respected but were in awe of nature, and were constantly frustrated by their apparent inability to capture its subtlety on the two-dimensional surface of a canvas. Renoir noted: "There is something in painting which cannot be

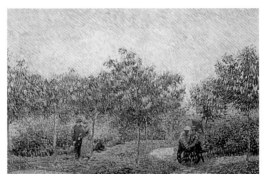

Vincent van Gogh
*The Park at Asnières
with Couples*
1887

explained, and that something is essential. You come to nature with your theories, and nature knocks them all flat." Some problems might be resolved artistically, however, as Cézanne suggested: "I wanted to copy Nature. And I failed. But I was content when I realized that (for example) the sun cannot simply be reproduced but must rather be expressed by some other means...by colour."

The fleeting "impression" of nature was the primary goal, as van Gogh elucidated:

> Of nature I retain a certain sequence and a certain correctness in placing the tones. I study nature so as not to do foolish things, to remain reasonable; however, I don't care so much whether my colour is exactly the same, as long as it looks beautiful on my canvas, as beautiful as it looks in nature...suppose I have to paint an autumn landscape, trees with yellow leaves. All right – when I conceive a symphony in yellow, what does it matter if the fundamental colour of yellow is the same as that of the leaves or not? It matters very little.

The Impressionists' palettes were ideally suited to depictions of bright sunlight, and their evolving style placed emphasis on the highly effective use of complementary colours: orange boats dancing on vivid blue water, shimmering grass sprinkled with crimson poppies, and autumnal foliage juxtaposed against blue water and sky. Dissolving colour, reflections, and, in particular, water fascinated the group, as Théodore Duret considered:

> The Impressionist sits on the bank of a river. The water takes on every possible hue, according to the state of the sky, the perspective, the time of the day, and the calmness or agitation of the air. Without hesitation he paints water which contains every hue.

The acknowledged master of the motif was Claude Monet, who even worked in a sort of "floating studio" in order to paint river subjects and devoted the final years of

his life to his famed water garden at Giverny. The poet Stéphane Mallarmé drew special attention to his enthusiasm and genius:

> Claude Monet loves water, and it is his special gift to portray its mobility and transparency, be it sea or river, grey and monotonous, or coloured by the sky. I have never seen a boat posed more lightly on the water than in his pictures, or a veil more mobile and light than his moving atmosphere. It is in truth a marvel.

Monet's fellow Impressionists followed their own inclinations in seeking favoured motifs and seasons. Renoir was at his greatest painting flowers and people at leisure in summer settings. Pissarro, while clearly possessing a strong affinity with autumn and winter landscapes, was one of the artists most conscious of all four seasons, commenting late in his life: "There is a spring, a summer, an autumn, winter, air, the light, harmonies, admirable and infinite subtleties in nature." He most characteristically painted evocative images of the cycle of the seasons in rural settings, from planting through to harvesting, depicting the rebirth of nature after winter in magnificent spring blossoms. Writing of one of Pissarro's flowering orchard paintings, Emile Zola considered that: "The painter's insight has wrested from daily truth a rare poem of life and strength." His joyful spring scenes, with topographically non-specific titles such as *Spring Landscape*, serve also to emphasize the relative importance of the season, rather than the precise location, as the subject of the painting.

The Impressionists sought subjects beyond simple landscapes, and their works record such everyday leisure activities as boating and

Camille Pissarro
Snow Scene at Eragny
1894

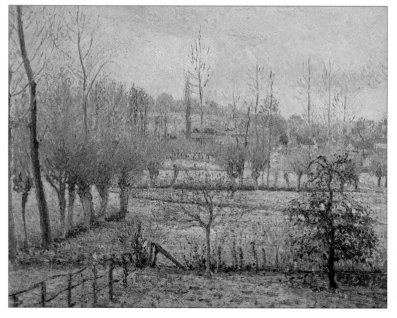

bathing, the pleasures of dining in sun-dappled gardens, outings into the countryside, picnics and walks through flower-strewn meadows. Into many of these paintings, they injected elements of modernity. However, Renoir's *Railway Bridge at Chatou*, or the encroaching industrialization viewed in Seurat's works, were not a critical response to such developments, but reflections of the new age: Pissarro was as delighted to paint bustling city streets as tranquil fields, and he and his colleagues depicted contemporary aspects of "progress", which faithfully took account of such diverse social changes as the newly established popularity of flower gardening as an amateur enthusiasm rather than a profession, and the desires of the town-dweller to maintain contact with his rural heritage.

At any season, capturing the elusive moment presented challenges as mists cleared, the sun vanished behind clouds, or rain and strong winds wrought havoc with large canvases. In 1888 van Gogh wrote: "Painting is hard work in this wind, but I secure my easel with poles which I put in the ground, and in this way I still manage to work – it's quite beautiful." Artists such as Monet were prepared to face the considerable hardships imposed by painting out of doors in adverse weather conditions, even during the depths of winter, in order to catch the fleeting impression of light on a snowy landscape or an ice-bound river: indeed, his magnificent series of paintings of the frozen Seine at Vétheuil resulted from work carried out on the river bank during the winter of 1879–80, which was the coldest of the entire nineteenth century in northern Europe.

The Impressionists portrayed not only the protean changes they observed between the seasons, but also within them – the transformation of motifs during the day, from sunrise to sunset, and virtually hour by hour. This reached its apogee with Monet's series paintings of poplars, Rouen cathedral, and in particular his paintings of grainstacks. Monet wrote to Gustave Geffroy in October 1890 of his progress with the latter theme:

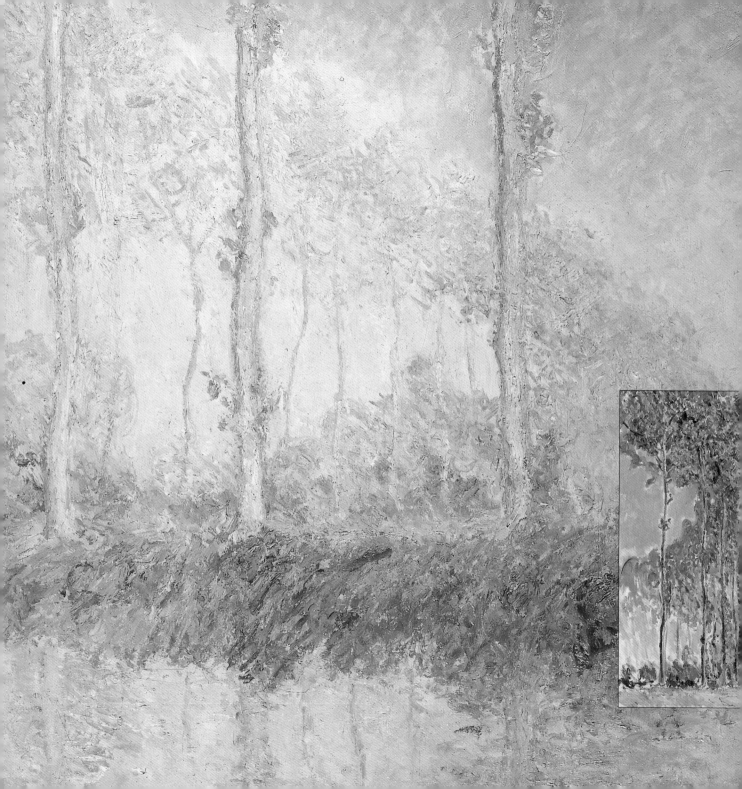

> I'm plugging away, toiling doggedly at a series of different effects, but at this time of year the sun goes down so fast that I can't keep up with it. I'm becoming so slow in my ways, it's maddening. But the further I go, the more I realize the amount of work involved in rendering what I'm after: the instantaneousness, the envelope of things, with the same light pouring in everywhere.

The result was vividly described by Geffroy in his introduction to the Monet exhibition of 1891, in which the paintings were first shown publicly:

> There are the multicoloured, sumptuous, and melancholy festive days of autumn. When the sky is overcast, trees and houses seem remote, like phantoms. In very clear weather, blue shadows, already cool, extend along the pink earth. At the close of warm days, after a persistent sunlight that appears to depart reluctantly, leaving behind a sprinkling of golden dust on the countryside, the haystacks glow in the confusion of evening like heaps of sombre gems...
>
> Finally, it is winter, with its threatening sky and the pure white silence of space: the snow is lit with a rosy light shot through with pure blue shadows... He is always the incomparable painter of earth and sky, preoccupied with fleeting light conditions on the permanent background of the universe... He tells tales of mornings, noondays, twilights, rain, snow, cold, sunshine. He hears the voices of the evening and he makes us hear them. Pieces of the planet take shape on his canvases.

Through their determined pursuit of such images, often in defiance of criticism, in the face of financial adversity, and in combat with the forces of nature itself, the Impressionists added to the established artistic repertoire a vast array of new motifs that had been overlooked by their predecessors and which were perpetuated by their successors, through Post-Impressionism and into the modern era. The result of this single-minded passion was a range of superb works that have become the most enduring and widely admired in the history of art.

Claude Monet

Below:
Poplars (view from the marsh)
1891

Opposite:
The Poplars (Autumn)
(detail) 1891

SPRING

For winter's rains and ruins are over,
And all the season of snows and sins;
The days dividing lover and lover,
The light that loses, the night that wins;
And time remembered is grief forgotten,
And frosts are slain, and flowers begotten,
And in green underwood and cover
Blossom by blossom the spring begins.

ALGERNON CHARLES SWINBURNE, *ATALANTA*

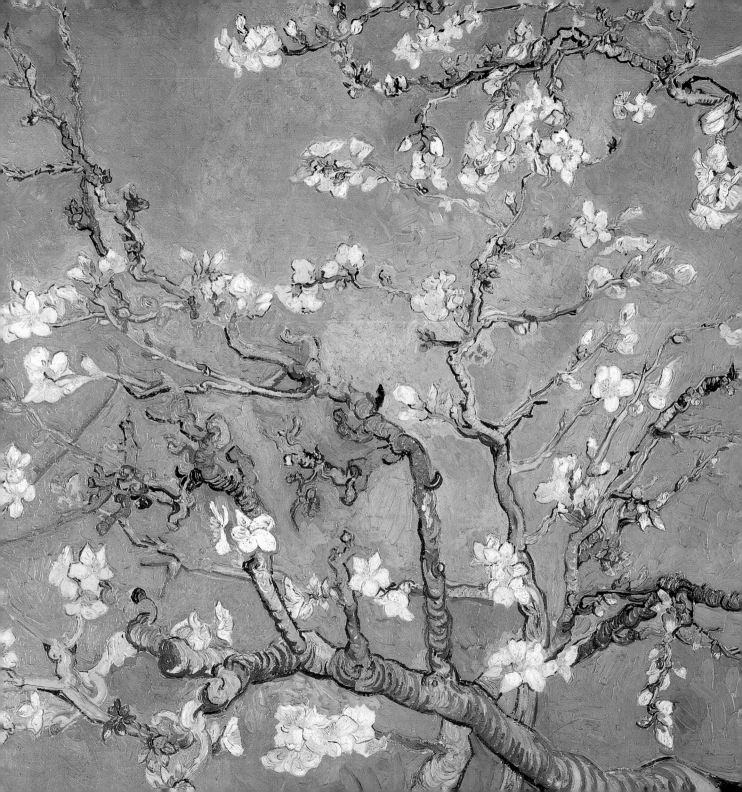

Traditional landscape is dead, killed by Life and Truth. No one nowadays would dare say that the sky and water are vulgar, or that a horizon has to be painted evenly and precisely if work of any beauty is to be created... Talented Naturalists, by contrast, interpret according to a personal view of things. They translate truths into a language of their own. Nature is still their yardstick, but they retain their individuality too. First and foremost they are human, and that humanity is involved in everything they paint. That is why their works will last.

EMILE ZOLA

Claude Monet

Tulip Fields with the Rijnsburg Windmill
1886

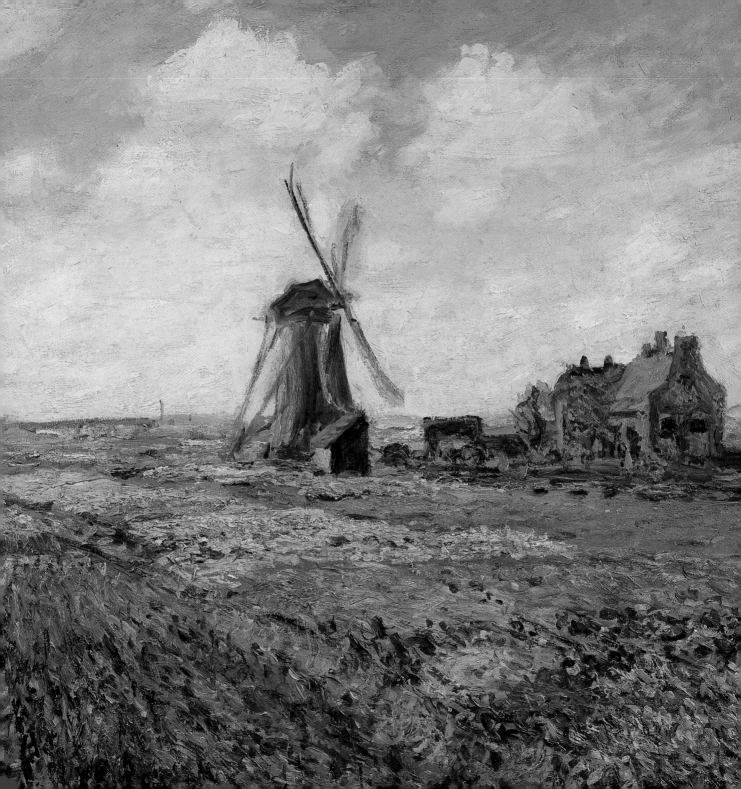

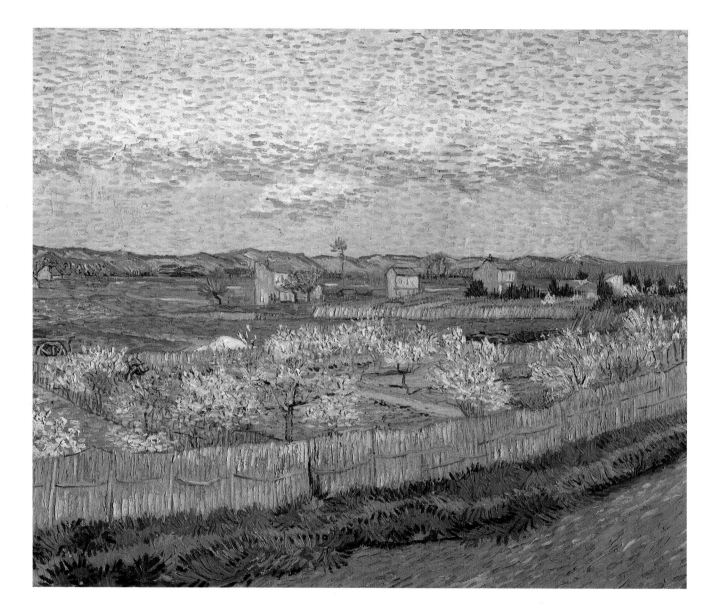

Beneath the crisp and wintry carpet hid
A million buds but stay their blossoming;
And trustful birds have built their nests amid
The shuddering boughs, and only wait to sing
Till one soft shower from the south shall bid,
And hither tempt the pilgrim steps of Spring.

ROBERT BRIDGES, *THE GROWTH OF LOVE*

Vincent van Gogh

*The Crau with Peach
Trees in Bloom*
1889

I have just come back with two studies of
orchards…the big one is a poor landscape with little
cottages, blue skyline of the Alpille [*sic*] foothills,
sky white and blue. The foreground patches of land
surrounded by cane hedges, where small peach trees
are in bloom – everything is small there, the
gardens, the fields, the orchards, and the trees, even
the mountains, as in certain Japanese landscapes,
which is the reason why the subject attracted me.

VINCENT VAN GOGH, LETTER TO PAUL SIGNAC

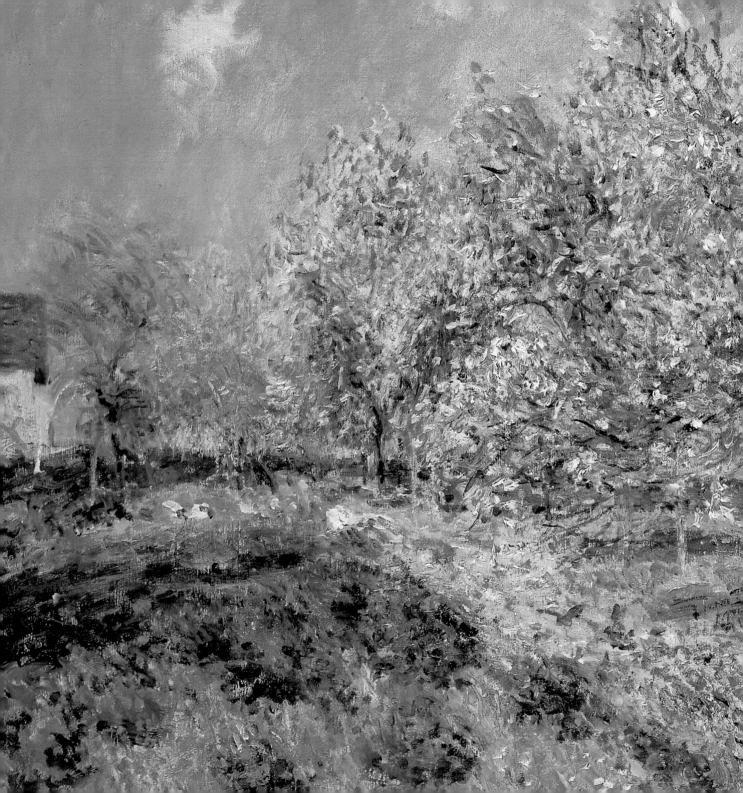

O thou, with dewy locks, who lookest down
Thro' the clear windows of the morning; turn
Thine angel eyes upon our western isle,
Which in full choir hails thy approach, O Spring!

The hills tell each other, and the list'ning
Valleys hear; all our longing eyes are turned
Up to thy bright pavillions: issue forth,
And let thy holy feet visit our clime.

Come o'er the eastern hills, and let our winds
Kiss thy perfumed garments; let us taste
Thy morn and evening breath; scatter thy pearls
Upon our love-sick land that mourns for thee.

O deck her forth with thy fair fingers; pour
Thy soft kisses on her bosom; and put
Thy golden crown upon her languish'd head,
Whose modest tresses were bound up for thee!

WILLIAM BLAKE, TO SPRING

O thou, with dewy locks, who lookest down
Thro' the clear windows of the morning; turn
Thine angel eyes upon our western isle,
Which in full choir hails thy approach, O Spring!

The hills tell each other, and the list'ning
Valleys hear; all our longing eyes are turned
Up to thy bright pavillions: issue forth,
And let thy holy feet visit our clime.

Come o'er the eastern hills, and let our winds
Kiss thy perfumed garments; let us taste
Thy morn and evening breath; scatter thy pearls
Upon our love-sick land that mourns for thee.

O deck her forth with thy fair fingers; pour
Thy soft kisses on her bosom; and put
Thy golden crown upon her languish'd head,
Whose modest tresses were bound up for thee!

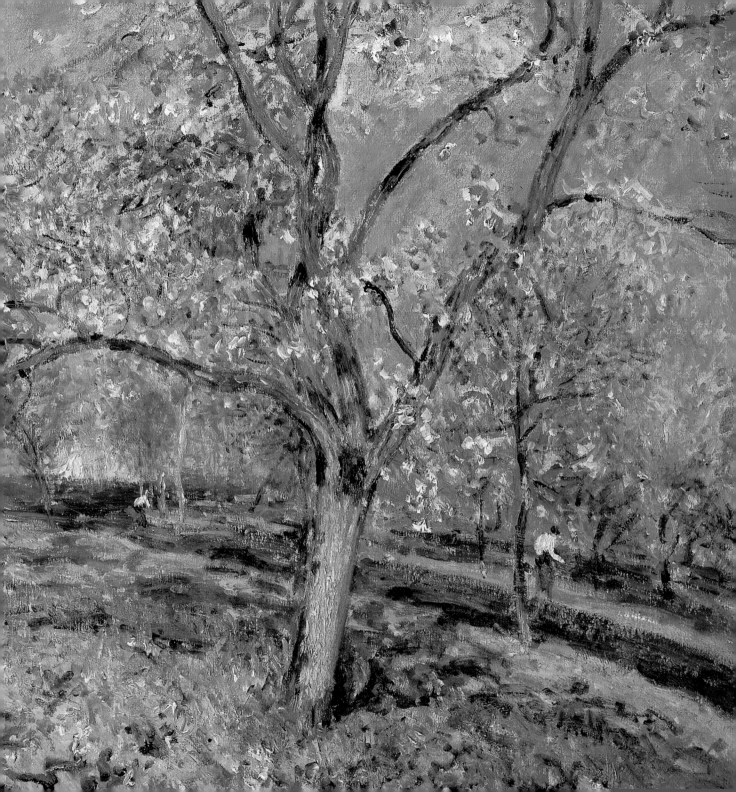

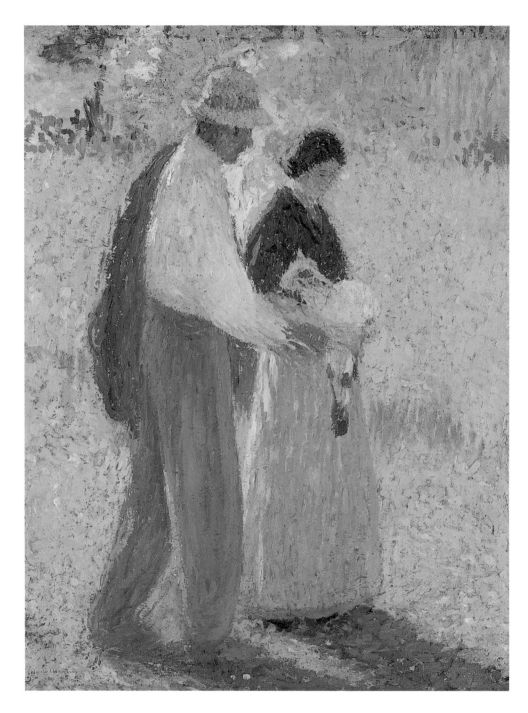

Henri Martin

Les fiancés avec un agneau

nd

What is all this juice and all this joy?

 A strain of the earth's sweet being in the beginning

In Eden garden. Have, get, before it cloy,

 Before it cloud, Christ, lord, and sour with sinning,

Innocent mind and Mayday in girl and boy,

 Most, O maid's child, thy choice and worthy the winning.

<div align="right">GERARD MANLEY HOPKINS, SPRING</div>

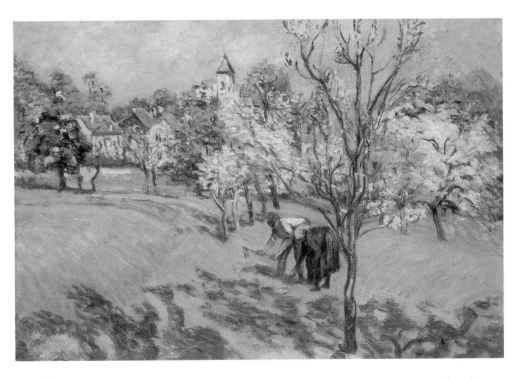

Armand Guillaumin

Two Peasants Sowing Beans in an Orchard
c.1895

The eye of the artist, like the mind of the thinker, discovers the larger aspects of things, their wholeness and unity. Even when he paints figures in scenes of rustic life, man is always seen in perspective in the vast, terrestrial harmony, like a human plant.

<div align="right">OCTAVE MIRBEAU</div>

Camille Pissarro
*Place du Theâtre
Français, Paris*
1898

I am delighted to be able to paint these Paris streets that people have come to call ugly, but which are so silvery, so luminous and vital.

<small>CAMILLE PISSARRO, LETTER TO LUCIEN PISSARRO</small>

*Fair fantastic Paris who wears boughs
Like plumes, as if man made them, – tossing up
Her fountains in the sunshine from the squares,
As dice i' the game of beauty, sure to win.*

<small>ELIZABETH BARRETT BROWNING, *AURORA LEIGH*</small>

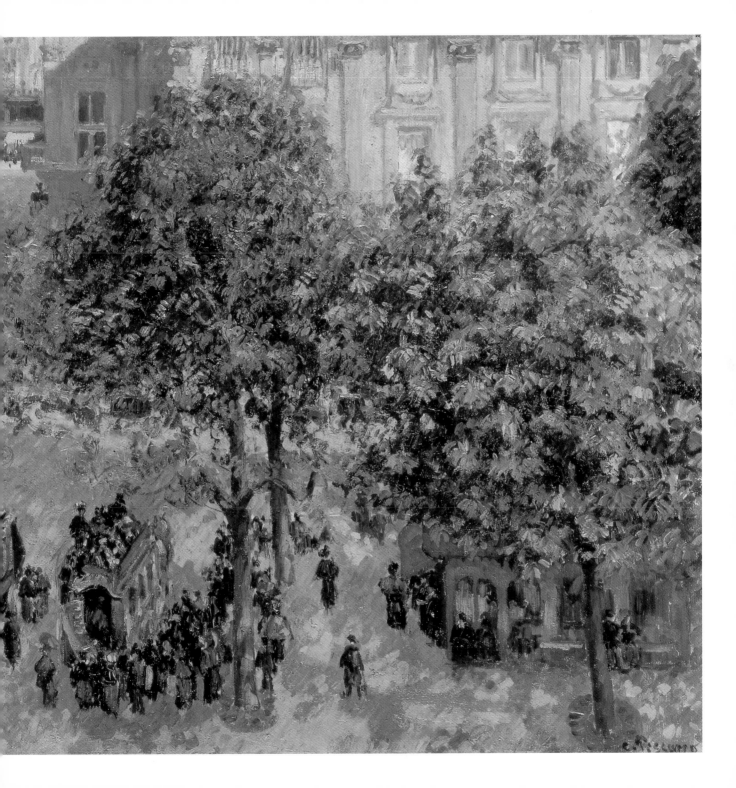

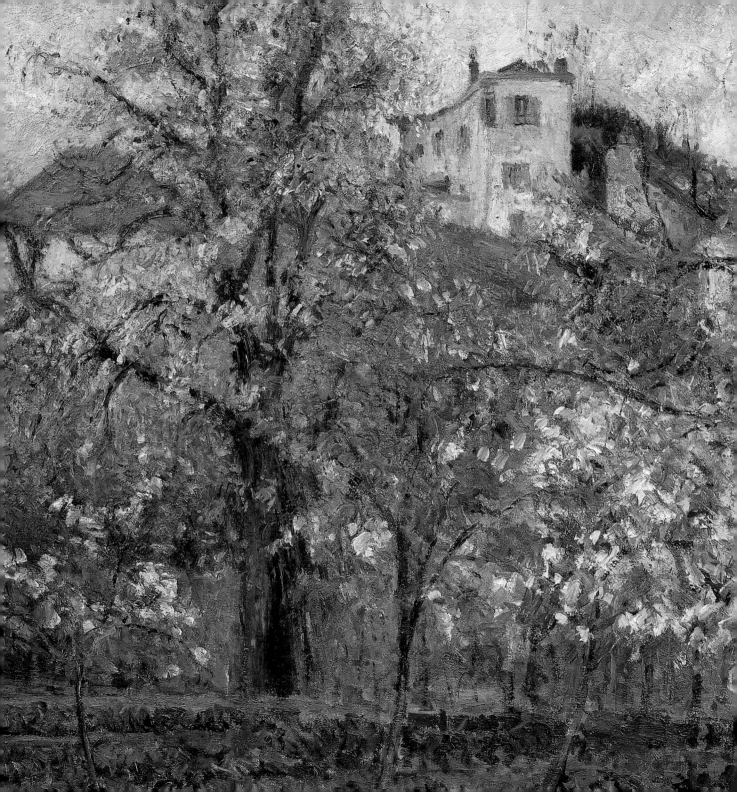

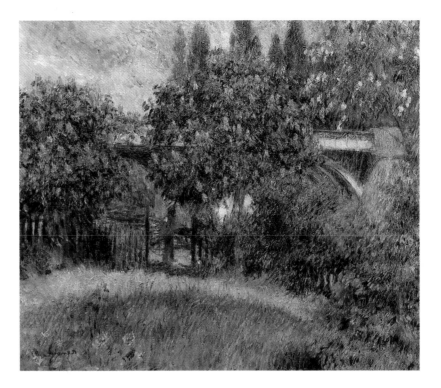

*Pissarro is sober and strong. His
synthesizing eye seizes up the
whole at a draught…. He also
has a deplorable liking for truck
gardens and does not shrink from
any presentation of cabbages or
other domestic vegetables. Yet
these defects of logic or these
vulgarities of taste do not detract
from his fine technical qualities.*

JULES CASTAGNARY

Unlike his companions in Impressionism, M. Renoir is a poet. Beneath the outward resemblance of his language and their own, the meaning of his art is quite different: it is an art whose main effect is not to arouse us in the illusion of a perfectly reproduced reality, but to release, for us, an image of this reality whose lines have greater sweetness, whose shades are at once lighter and more vivid, where the siren song of an eternal spring floats on the air.

TÉODOR DE WYZEWA

SUMMER

A thousand flowers – each seeming one
That learnt by gazing on the sun
 To counterfeit his shining;
Within whose leaves the holy dew
 That falls from heaven, has won anew
A glory, in declining.

ELIZABETH BARRETT BROWNING, *A FLOWER IN A LETTER*

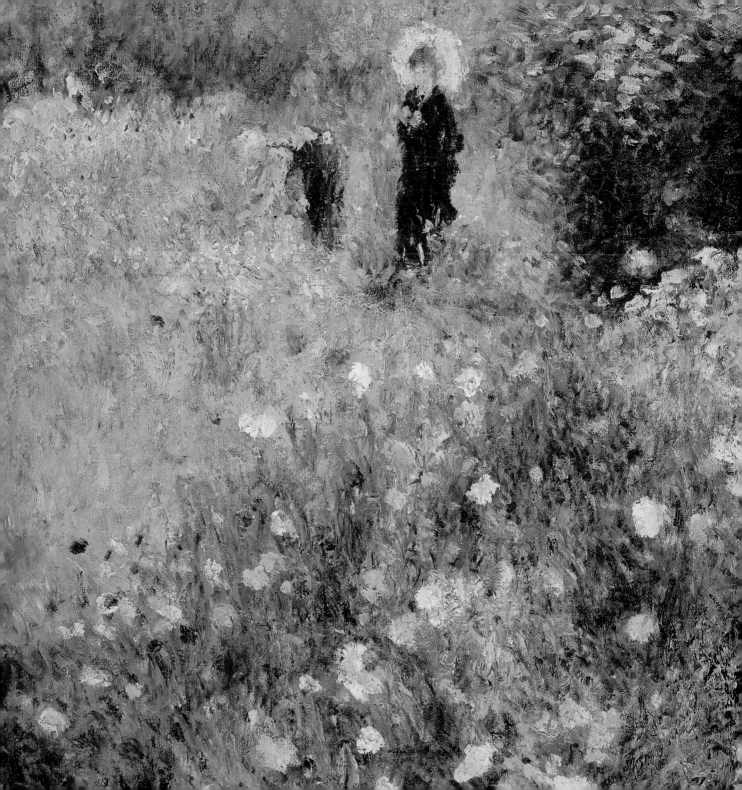

Claude Monet has a special affection for nature that the human hand has dressed in a modern style. He has painted a series of canvases, executed in gardens. I know of no paintings that have a more personal accent, a more characteristic look. The flower beds, dotted with the bright reds of geraniums and the flat whites of chrysanthemums, stand out against the yellow sand of the path... I would love to see one of these paintings at the Salon, but is seems that the jury is there to scrupulously prohibit their admittance. But so what? They will endure as one of the great curiosities of our art, as one of the marks of our era's tendencies.

EMILE ZOLA, *L'ÉVÉNEMENT*

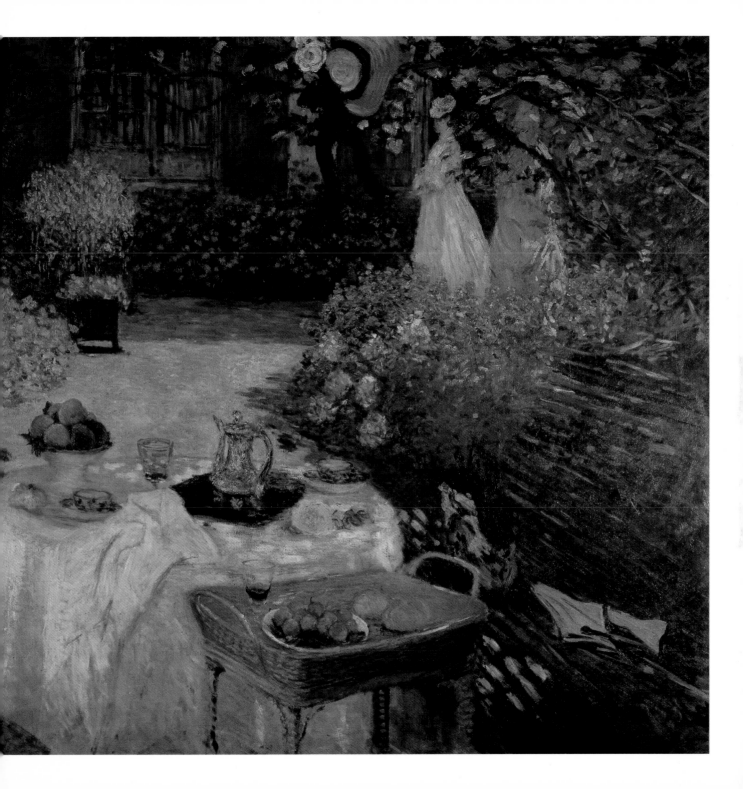

Once on a time, I know not where,
I know not when. A dream, may be,
Out of a pine wood, unaware,
I stepped upon a quiet lea.

And on the quiet meadow I
Saw all around a carpet spread,
Far as the line where land meets sky,
Of motionless blown poppies red.

And on the blood-red carpet lay,
Regarded of a thousand flowers,
A lovely, tired summer day
In first sleep of the sunset hours.

No breath, No sound. A bird in flight
The air of evening scarce does cleave,
I scarcely see his stretched wings smite,
A black line in the fragrant eve.

Once on a time, I know not when,
Long, long ago. A dream, may be,
But I can see it now as then,
The silent, purple poppy-sea.

GUSTAV FALKE, *THE POPPY FIELD*

Once on a time, I know not where,
I know not when. A dream, may be,
Out of a pine wood, unaware,
I stepped upon a quiet lea.

And on the quiet meadow I
Saw all around a carpet spread,
Far as the line where land meets sky,
Of motionless blown poppies red.

And on the blood-red carpet lay,
Regarded of a thousand flowers,
A lovely, tired summer day
In first sleep of the sunset hours.

No breath, No sound. A bird in flight
The air of evening scarce does cleave,
I scarcely see his stretched wings smite,
A black line in the fragrant eve.

Once on a time, I know not when,
Long, long ago. A dream, may be,
But I can see it now as then,
The silent, purple poppy-sea.

GUSTAV FALKE, THE POPPY FIELD

Claude Monet
Poppy Field in a Hollow
near Giverney (detail)
1885

Art is the child of Nature; yes,

Her darling child, in whom we trace

The features of the mother's face,

Her aspect and her attitude;

All her majestic loveliness

Chastened and softened and subdued

Into a more attractive grace,

And with a human sense imbued.

He is the greatest artist then,

Whether of pencil or of pen,

Who follows Nature. Never man,

As artist or as artisan,

Pursuing his own fantasies,

Can touch the human heart, or please,

Or satisfy our nobler needs,

As he who sets his willing feet

In Nature's footprints, lights and fleet,

And follows fearless where she leads.

HENRY WADSWORTH LONGFELLOW, *KÉRAMOS*

Claude Monet

*The Poppy Field
near Argenteuil*
1873

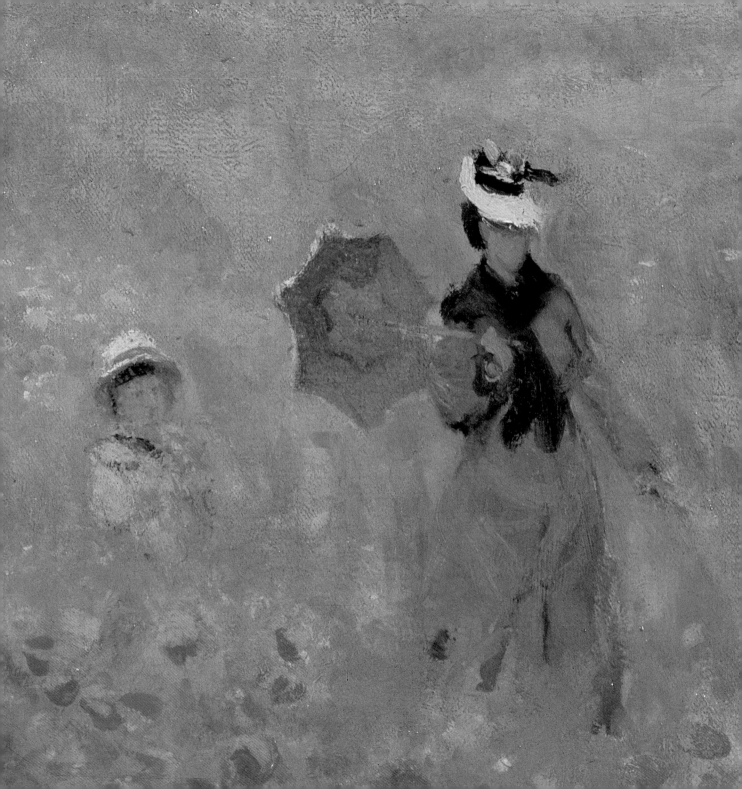

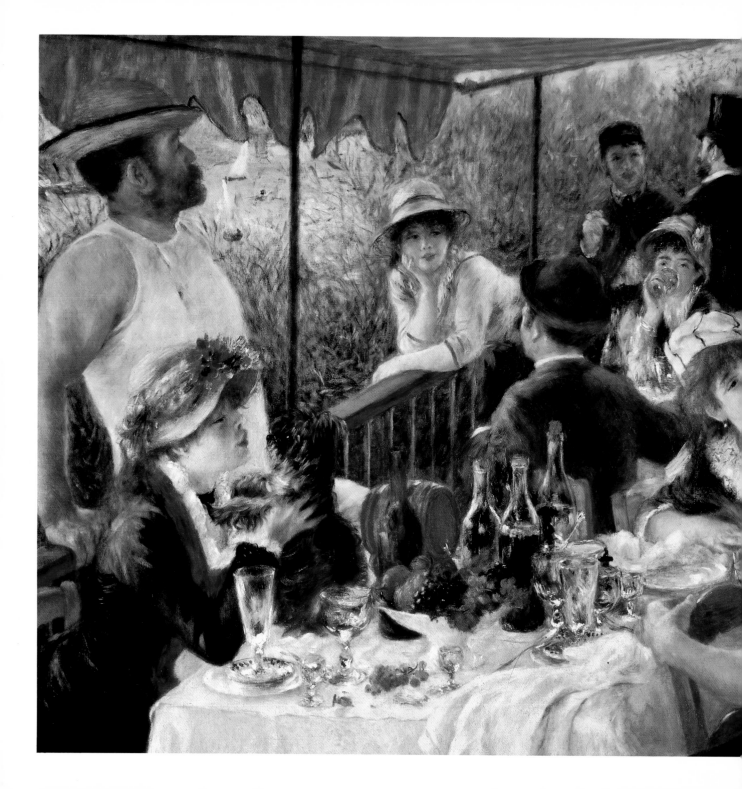

The Impressionists show their particular talent and attain the summit of their art when they paint our French Sundays… kisses in the sun, picnics, complete rest, not a thought about work, unashamed relaxation.

RENÉ GIMPEL

Auguste Renoir
Luncheon of the Boating Party
1881

It is a page of history, a rigorously precise and precious monument to Parisian life. No one before him has dreamt of noting the existence of everyday life on such a grand scale of canvas. It is a historic picture. M. Renoir and his friends have discovered that history painting is not the illustration, more or less, of droll tales from the past…What documents will these artists who deliver us from such lubrications bequeath to future centuries for the history of our times!

GEORGES RIVIÈRE

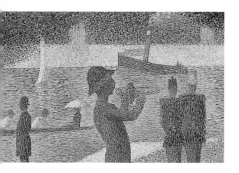

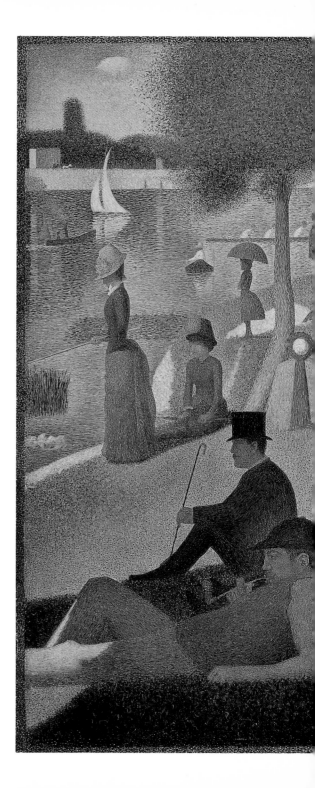

A canicular sky, at four o'clock, summer, boats floating by to the side, a dispersed group of chance Sunday visitors enjoying the fresh air among the trees... The atmosphere is transparent and singularly vibrant; the surface seems to flicker.

FÉLIX FÉNÉON

*He is a saint of Sunday in the open air, a
fanatic disciplined
By passion, courage, passion, skill,
compassion, love: the love of life
and the love of light as one, under the
sun, with the light of life.*

DELMORE SCHWARZ, SEURAT'S SUNDAY AFTERNOON ALONG THE SEINE

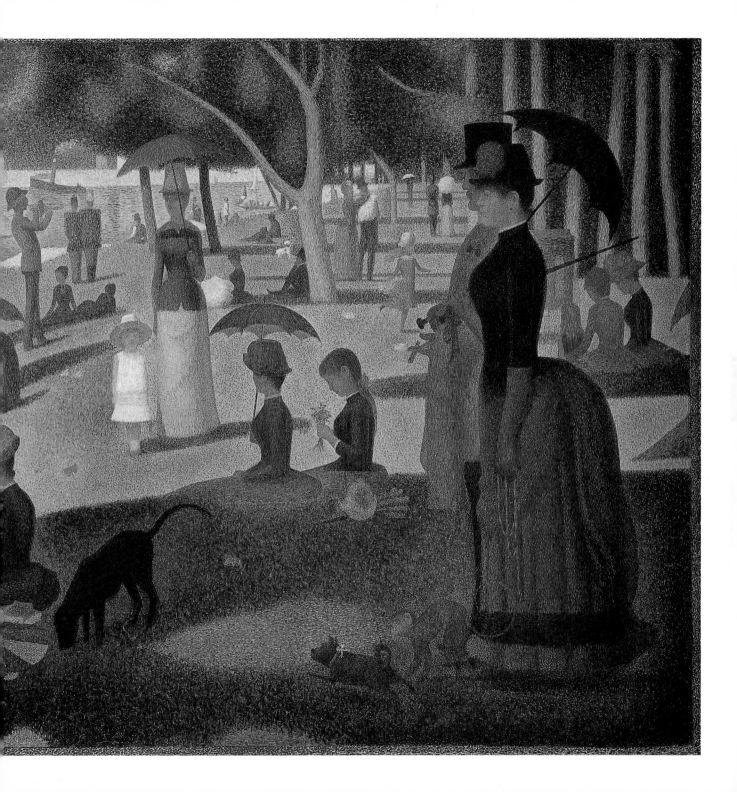

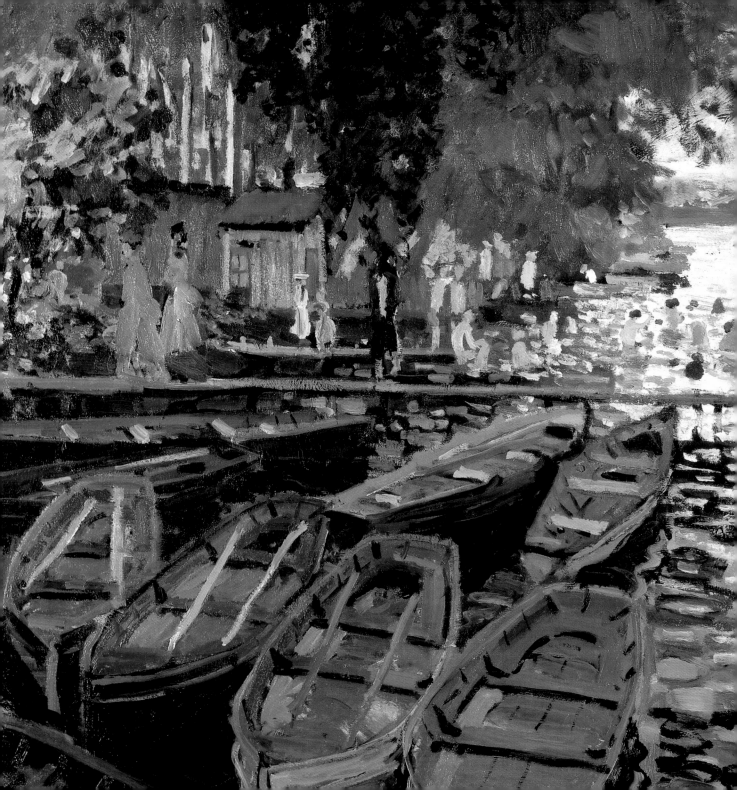

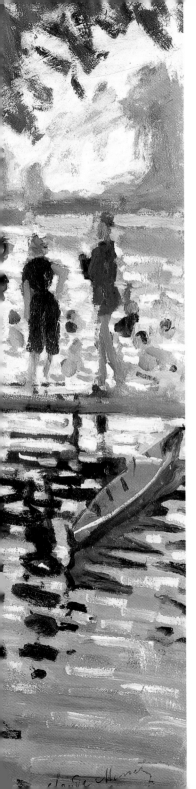

It was at La Grenouillère, the café by the Seine, that Impressionism was born.

KENNETH CLARK

Here I've come to a standstill, from lack of paints! I alone this year will have done nothing. It makes me rage against everyone... I have a dream, a picture of bathing at La Grenouillère, for which I've made some bad sketches, but it's a dream. Renoir, who has been spending two months here, also wants to do this picture.

CLAUDE MONET, LETTER TO FRÉDERIC BAZILLE

The customers seated at the tables swallow red, white, yellow and green liquids...a swimmer appears on the roof each second and jumps into the water, splashing those nearby who respond with wild cries.

GUY DE MAUPASSANT, YVETTE

Claude Monet
Bathers at La Grenouillère
1869

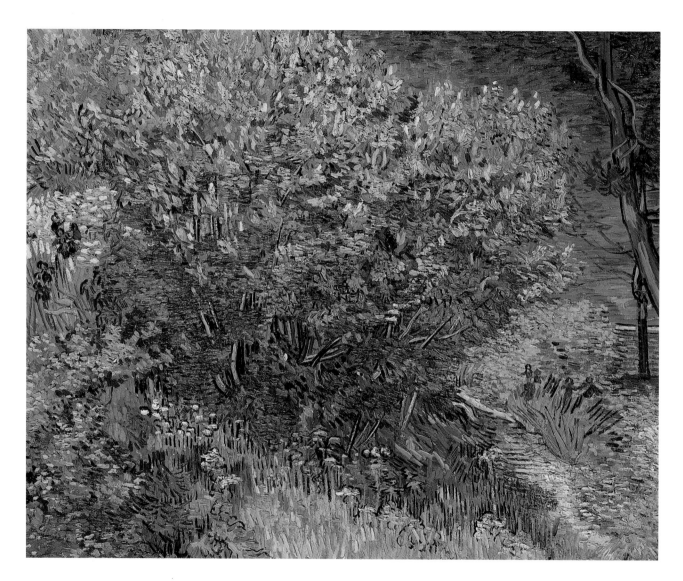

Vincent van Gogh

Lilac Bush
1889

Had I a garden, it should lie
All smiling to the sun,
And after bud and butterfly
Children should romp and run;
Filling their little laps with flowers,
The air with shout and song,
While golden-crests in guelder bowers
Rippled the whole day long.

ALFRED AUSTIN, *THE GARDEN THAT I LOVE*

Pierre-Auguste Renoir
Garden in the rue Cortot,
Montmartre
1876

As soon as Renoir crossed the threshold, he was delighted with the sight of the garden, which looked like a beautiful neglected park. Passing through the narrow hall of the little house, one found oneself facing a huge lawn of unmown grass dotted with poppies, convolvulus and daisies. Beyond that, a fine avenue of mature trees and beyond that again an orchard and vegetable garden, then a shrubbery.

GEORGES RIVIÈRE

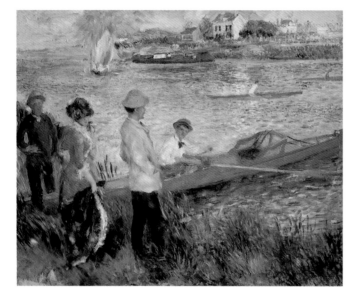

Pierre-Auguste Renoir
Oarsmen at Chatou
1879

It was by living in the open
air that he [Renoir] became
an open-air painter. The four
cold walls of the studio did
not press in on him; the
uniform brown and grey
tones of the walls did not
dull his eye. Also the
atmosphere and surroundings
had an enormous influence
upon him; having no
memory of the kind of
servitude to which artists so
often bind themselves, he let
himself be set in motion by
his subject and above all by
the character of the place he
was in.
EDMOND RENOIR

Mary Cassatt
The Boating Party
c.1893

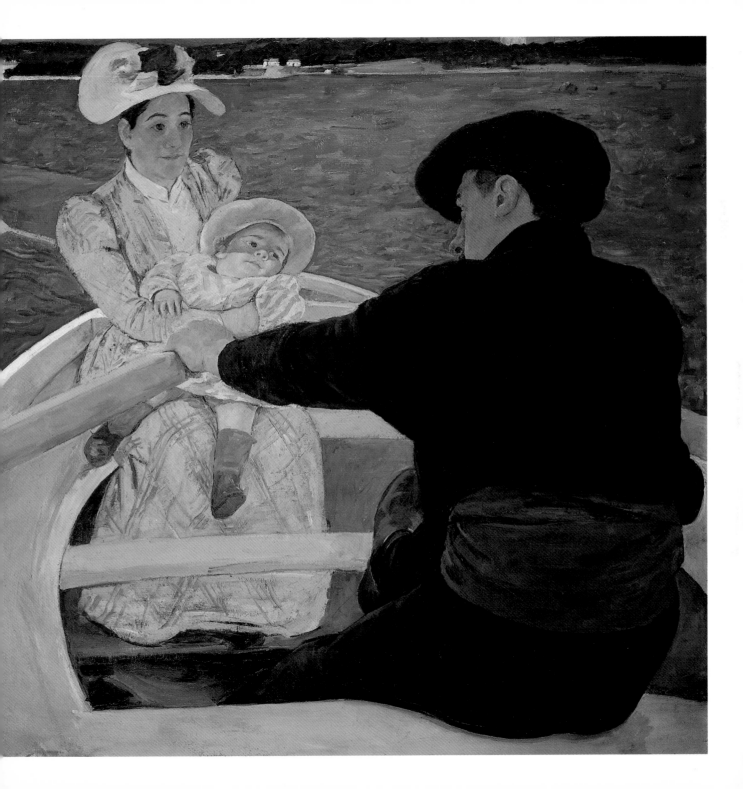

Edouard Manet

Argenteuil
1874

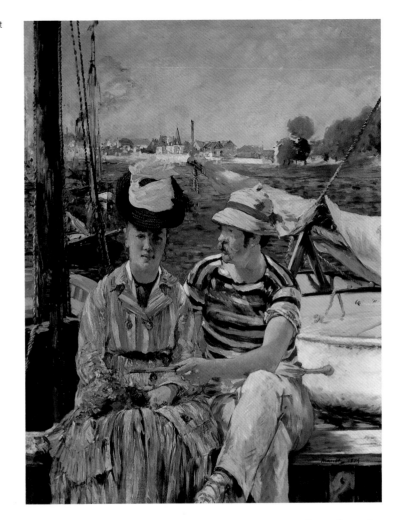

Below and (detail) left:

Claude Monet

Regatta at Argenteuil
c.1872

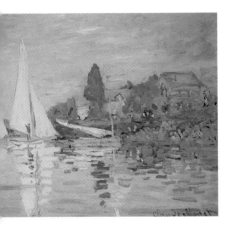

Monet feels the need to rigorously close the space in order to raise to the skies those luminous filaments, the masts of the sailing boats and their reflection in the water; they are not simple fireworks for they are too pure, too intimate, the very voices of the soul... They are Monet's moments of grace, the legends of his colour, the contemplation of the wonderful thing the world is.

LIONELLO VENTURI

The bright blue water continues to exasperate a number of people. Water isn't that colour? I beg your pardon, it is, at certain times, just as it has green and grey times, just as it contains lavender, and slate-grey, and light-buff reflections at other times. One must make up one's own mind to look about. And there lies one of the great errors of contemporary landscape painters who, coming upon a river with a preconceived formula, do not establish between it, the sky reflected in it, the position of the banks which border it, the time and season as they are at the moment they are painting, the necessary accord which nature always establishes. Manet has never, thank heavens, known those prejudices stupidly maintained in the academies. He paints, by abbreviations, nature as it is and as he sees it.

J.-K. HUYSMANS

From intuition to intuition, they [the Impressionists] have succeeded little by little in splitting up sunlight into its beams, its elements, and in recomposing its unity by means of the general harmony of the colours of the spectrum which they have spread on their canvases. From the point of view of delicacy of eye, of subtle penetration of the art of colour, it is an utterly extraordinary result. The most erudite physicist could not quarrel with their analysis of light.

<div align="right">EDMOND DURANTY</div>

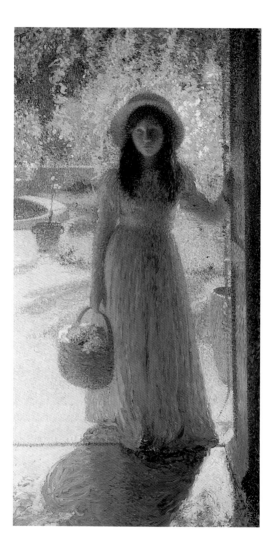

Henri Martin

Gabrielle à la Porte du Jardin
1910

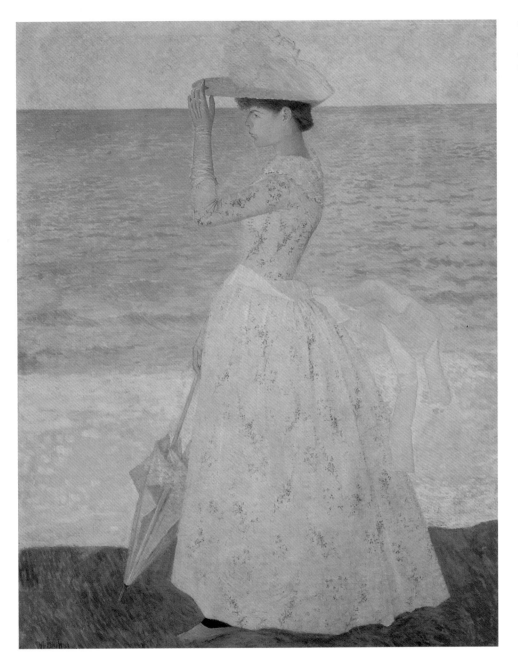

Aristide Maillol

*Woman with a
Sunshade*
c.1895–1900

I work as if no
art has ever
before been
created, as if I
have never
before been
taught anything.
I am the first
sculptor.

ARISTIDE MAILLOL

Henry van der Velde
Blankenbergue
1888

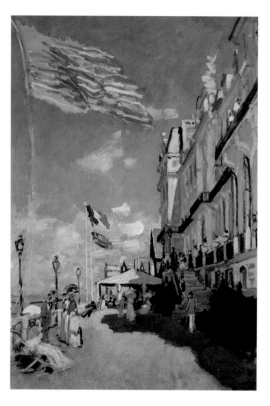

Claude Monet

*The Hotel
Roches-Noires
at Trouville*
1870

O summer day beside the joyous sea!
O summer day so wonderful and white,
So full of gladness and so full of pain!
Forever and forever shalt thou be
To some a gravestone of a dead delight,
To some a landmark of a new domain.

HENRY WADSWORTH LONGFELLOW,
A SUMMER DAY BY THE SEA

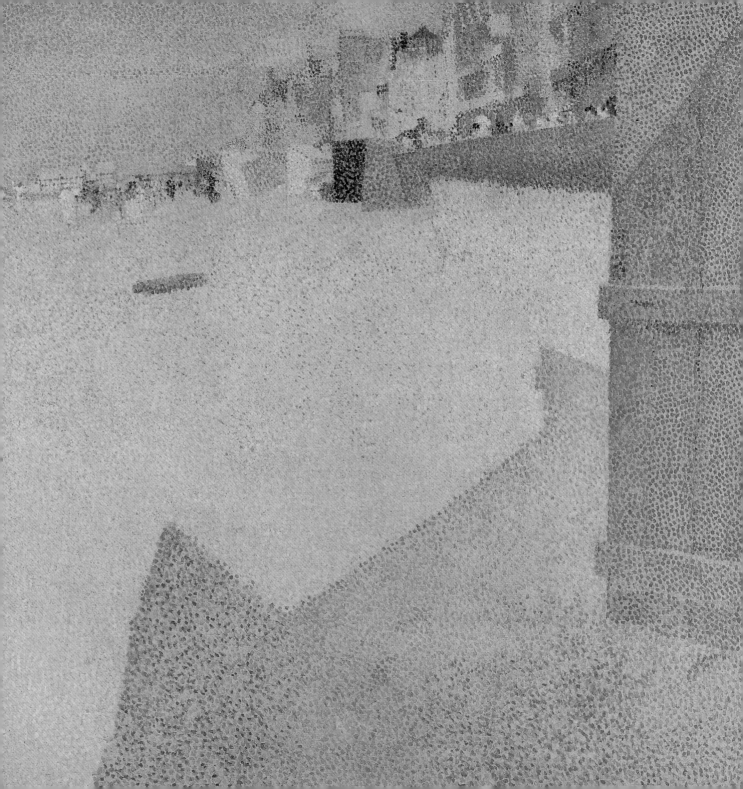

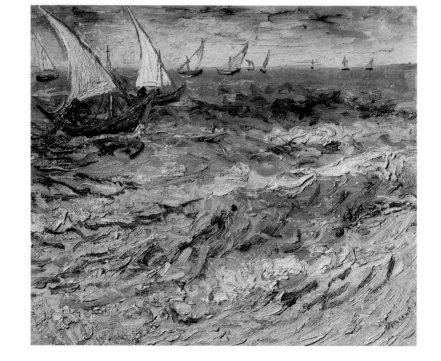

The Mediterranean has the colour of mackerel, changeable I mean. You don't always know if it is green or violet, you can't even say it's blue, because the next moment the changing reflection has taken on a tint of rose or grey.

VINCENT VAN GOGH, LETTER TO THEO VAN GOGH

Vincent van Gogh

*Sailing Boats at
Saintes-Maries*
1888

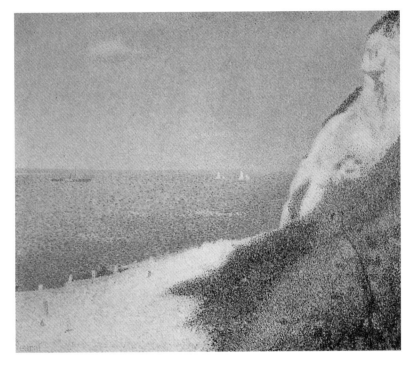

The views of the sea he exhibits...views of Honfleur...affirm the very real talent of which he has already provided indisputable proof. These images still rely on the sensation they express, of a nature more apathetic than melancholy, a nature calmly at ease under peaceful skies, sheltered from the wind... Strange indeed!

J.-K. Huysmans

Georges Seurat
The Beach at Le Bas-Butin, Honfleur
1886

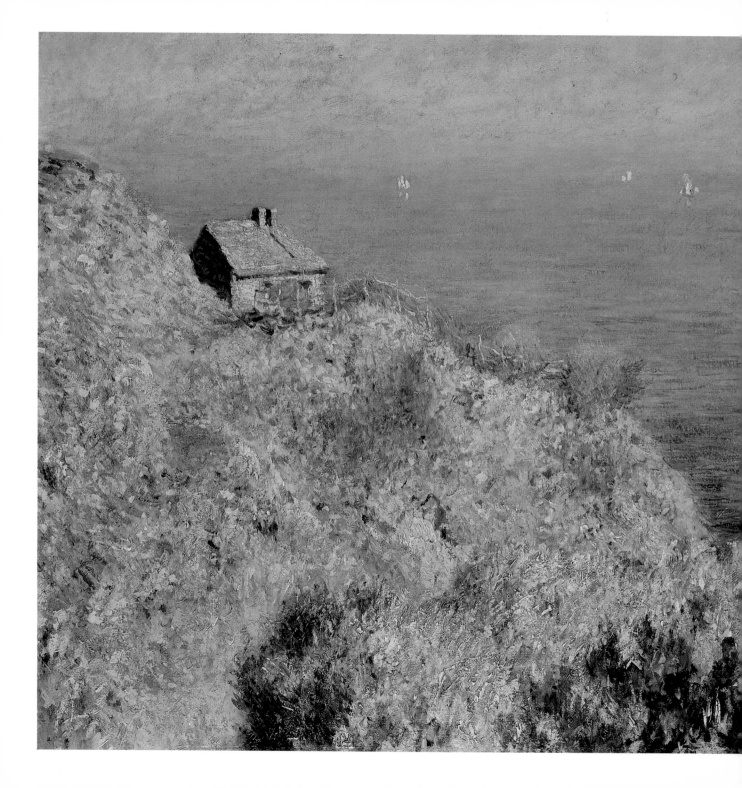

Claude Monet

The Customhouse Officer's Cabin at Varengeville
1882

It is just the environment one would have imagined for this extraordinary painter of the living splendour of colour, for this extraordinary poet of tender light and veiled shapes, for this man whose paintings breathe, are intoxicating, scented; this man who has touched the intangible, expressed the inexpressible, and whose spell over our dreams is the dream that nature so mysteriously enfolds, the dream that so mysteriously permeates the divine light...this painter of the western mists, of snowy winters glittering with frost, of the ocean's vast and terrible rhythms...this bard inspired by rose-pink springtimes and mother-of-pearl dawns, by the restless glimmers of transparent waters.

OCTAVE MIRBEAU

AUTUMN

Season of mists and mellow fruitfulness,
Close bosom-friend of the maturing sun;
Conspiring with him how to load and bless
With fruit the vines that round the thatch-eaves run;
To bend with apples the moss'd cottage-trees,
And fill all fruit with ripeness to the core;
To swell the gourd, and plump the hazel shells
With a sweet kernel; to set budding more,
And still more, later flowers for the bees,
Until they think warm days will never cease;
For Summer has o'erbrimm'd their clammy cells.

JOHN KEATS, *ODE TO AUTUMN*

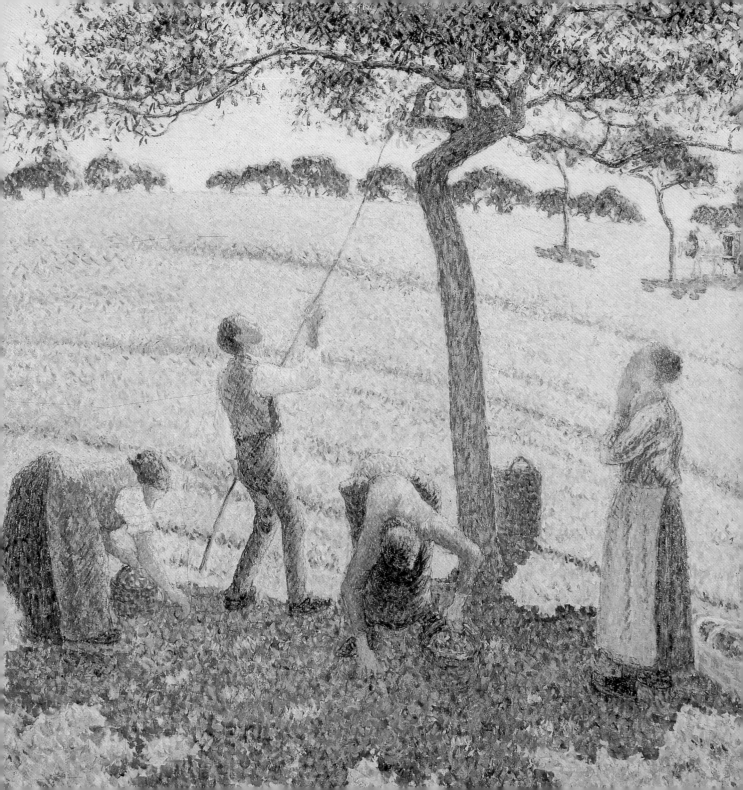

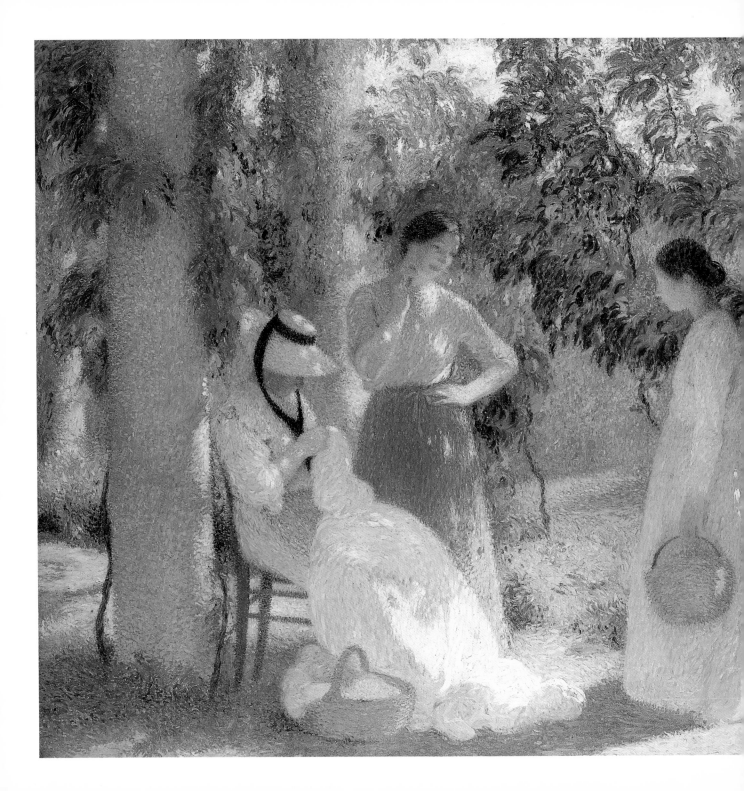

Henri Martin

*Scene de Couture –
Sous la Pergola à
Marquayrol*
1912

It was autumn. On both sides of the path, the harvested fields stretched off into the distance, golden with the stubble of oats and the wheat still lying on the ground... What one loves most about these aimless walks is the countryside...the woods, the rising sun, the dusk, the moonlight. For painters, walks are honeymoons with the earth. During these long tranquil expeditions, they are alone with their beloved. They can lie down in a prairie, brimming with daisies and poppies, and, warmed by the sun's radiance, contemplate a tiny village in the distance, as its steeple's bells ring out that it is noon.

GUY DE MAUPASSANT, *MISS HARRIET*

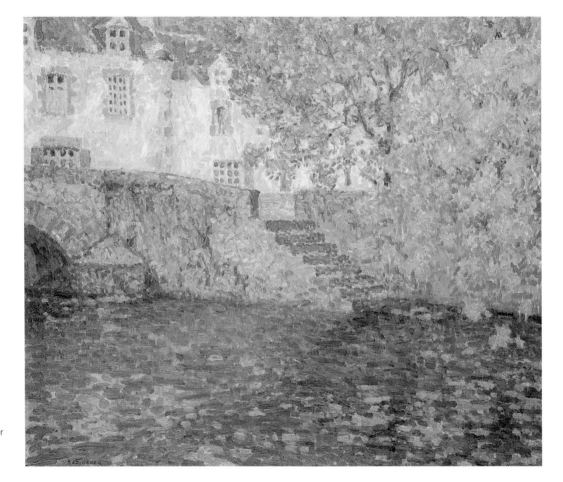

Henri Le Sidaner
Automne Doré
1923

There is a harmony

In autumn, and a lustre in its sky,

Which through the summer is not heard or seen,

As if it could not be, as if it had not been!

PERCY BYSSHE SHELLEY, *HYMN TO INTELLECTUAL BEAUTY*

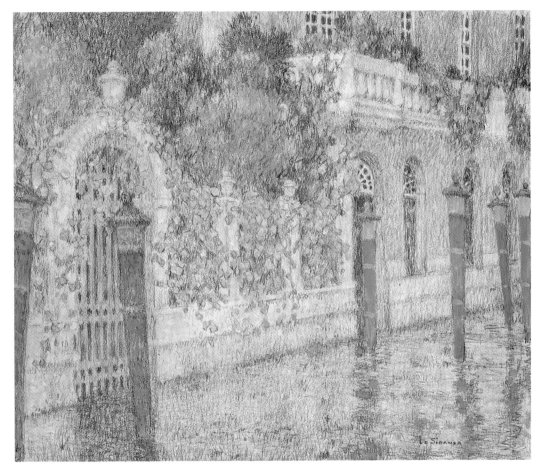

Henri Le Sidaner

*Le Palais Blanc,
Automne, Venise*
c.1906–7

After the wet, the colours upon the walls and their reflections in the canals are more gorgeous than ever – and with the sun shining on the polished marble mingled with the rich toned bricks and plaster, this amazing city of palaces becomes really a fairy land – created one would think especially for the painter.

JAMES WHISTLER, LETTER TO HIS MOTHER

The golden-rod is yellow;
 The corn is turning brown;
The trees in apple orchards
 With fruit are bending down.

The gentian's bluest fringes
 Are curling in the sun;
In dusty pods the milkweed
 Its hidden silk has spun.

The sedges flaunt their harvest,
 In every meadow nook;
And asters by the brook-side
 Make asters in the brook,

From dewy lanes at morning
 The grapes' sweet odors rise;
At noon the roads all flutter
 With yellow butterflies.

By all these lovely tokens
 September days are here,
With summer's best of weather,
 And autumn's best of cheer.

But none of all this beauty
 Which floods the earth and air
Is unto me the secret
 Which makes September fair.

'T is a thing which I remember;
 To name it thrills me yet:
One day of one September
 I never can forget.

HELEN JACKSON, *September*

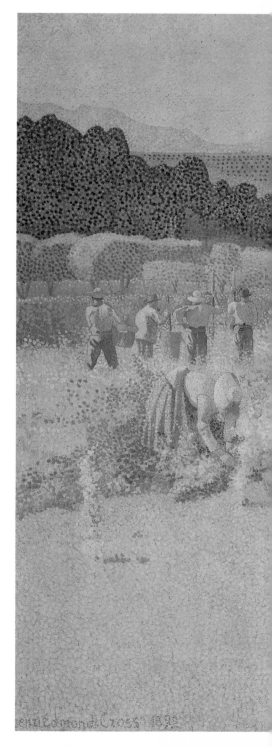

Henri Cross
Grape Harvest
c.1892

Pierre-Auguste Renoir
The Vintagers
1879

*To describe the drama of
the earth and to move our
hearts, M. Pissarro does
not need violent gestures,
complicated arabesques and
sinister branches against
livid skies… An orchard,
with its apple trees in rows,
its brick houses in the
background and some
women under the trees,
bending and gathering the
apples which have fallen to
the ground, and a whole
life is evoked, a dream rises
up, soars, and such a
simple thing, so familiar to
our eyes, transforms itself
into an ideal vision,
amplified and raised into a
great decorative poetry.*

OCTAVE MIRBEAU

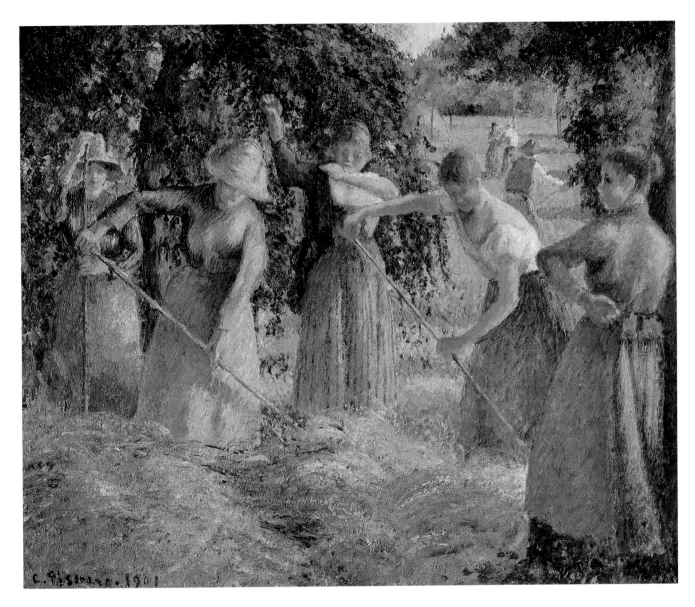

Camille Pissarro

Haymaking at Eragny

1901

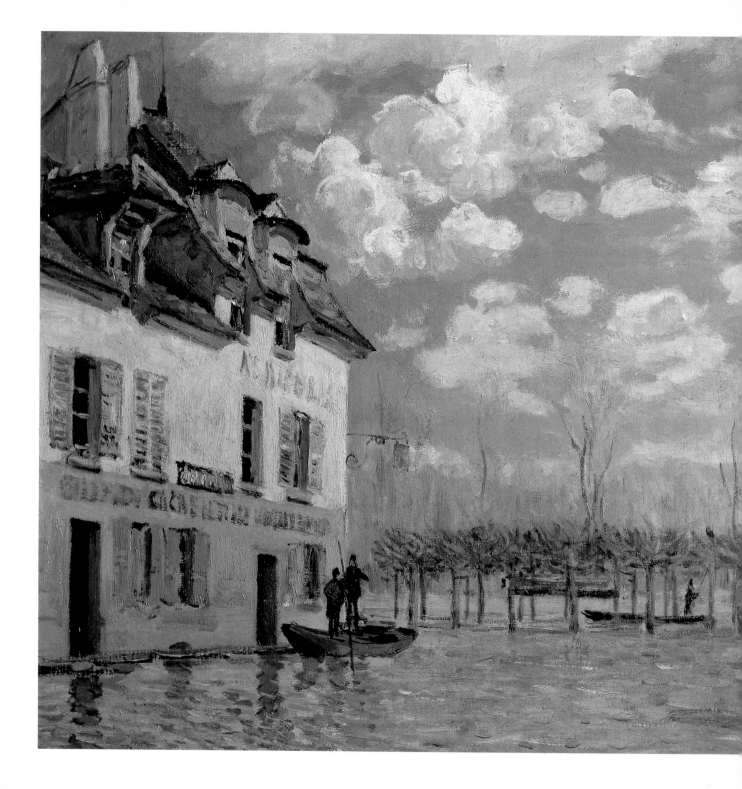

Alfred Sisley
*The Boat during the
flood at Port-Marly*
1876

Alfred Sisley
Le Canal du Loing
1892

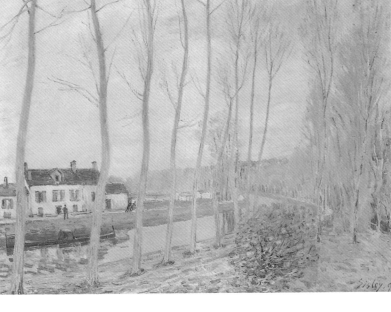

*Sisley is a great
and beautiful
artist; in my
opinion, he is a
master equal to the
greatest. I have
seen works of his
of rare amplitude
and beauty, among
others a Flood
which is a
masterpiece.*

CAMILLE PISSARRO

Objects should be shown in their particular contexts, and must be enveloped in light, just as in nature...the means will be the sky (the sky is never a mere background). Not only does it give the picture depth in its successive planes (the sky, just like the earth, has planes) but also by its form, and its relationship with the whole composition, it gives movement... I always begin a picture with the sky.

ALFRED SISLEY

67

Water takes pride of place in Monet's work. He is the painter of water *par excellence*. In older landscape paintings, water looks motionless and monotonous with its "water" colour, like a simple mirror to reflect objects. In Monet's paintings, water no longer has its own unvaried colour. It takes on an infinite variety of appearances according to the condition of the atmosphere, the type of bed over which it flows, or the silt that it carries along. It can be clear, opaque, calm, agitated, fast-flowing or sleepy, depending on the temporary conditions observed by the artist as he sets his easel before its liquid surface.

THÉODORE DURET, *THE IMPRESSIONIST PAINTERS*

Claude Monet

Autumn Effect at
Argenteuil

1873

Water takes pride of place in Monet's work. He is the painter of water par excellence. In older landscape paintings, water looks motionless and monotonous with its "water" colour, like a simple mirror to reflect objects. In Monet's paintings, water no longer has its own unvaried colour. It takes on an infinite variety of appearances according to the condition of the atmosphere, the type of bed over which it flows, or the silt that it carries along. It can be clear, opaque, calm, agitated, fast-flowing or sleepy, depending on the temporary conditions observed by the artist as he sets his easel before its liquid surface.

THEODORE DURET, THE IMPRESSIONIST PAINTERS

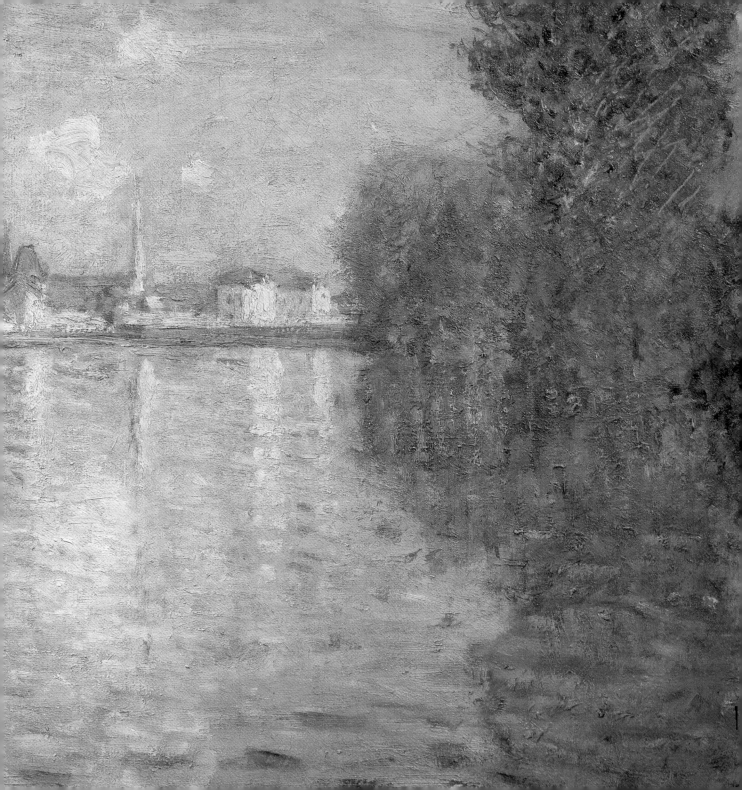

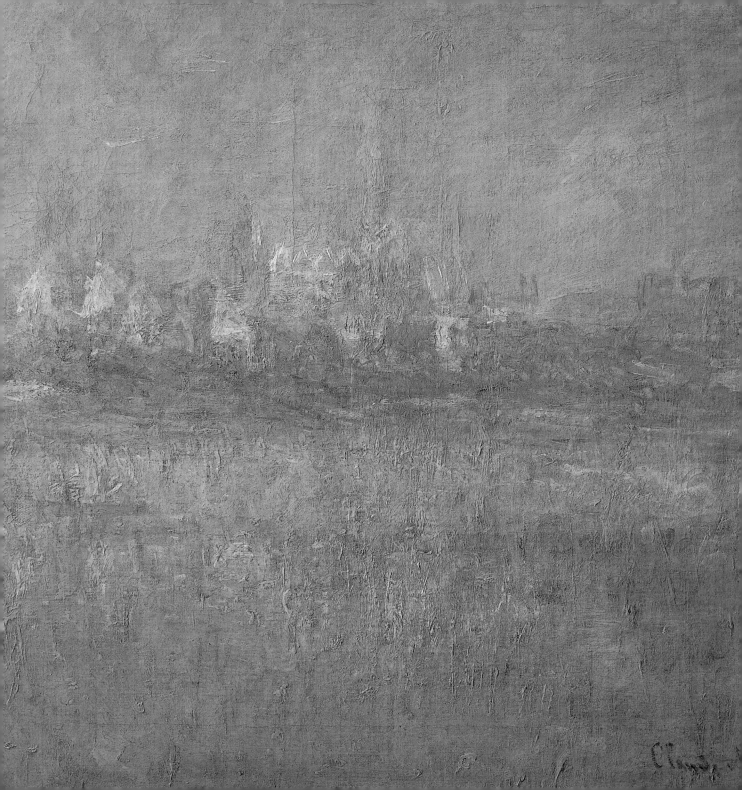

Claude Monet
Vétheuil in the Fog (detail)
1879

Matter…often seems to dissolve itself into reflexes, when light seems to be as real and tangible as the object it falls on. Thus churches, palaces and bridges look like as many curtains of coloured light quivering ceaselessly in the mirror of the water. In this half aquatic, half terrestrial atmosphere, nature changes altogether and, imitating art, offers us sights as usual and shifting as the best Impressionist paintings.

JOHN WALKER

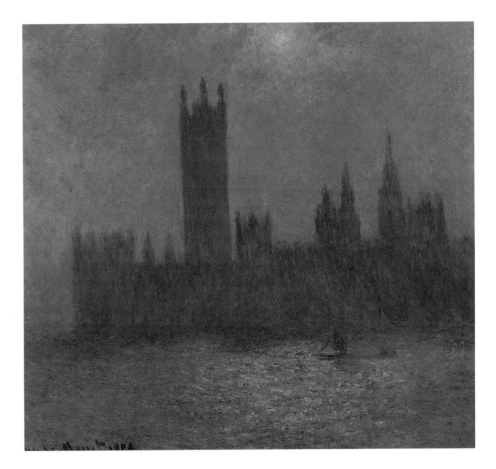

Claude Monet
Houses of Parliament, Effect of Sunlight in the Fog
1904

71

Pierre-Auguste Renoir
Umbrellas (detail)
c.1881–85

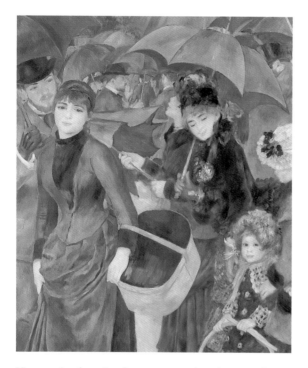

He remained as simple a man as when he started out, unsusceptible to vanity or flattery, unconcerned about honours...There was an occasion, however when he was visibly moved by a tribute. It was in July 1917. One of his paintings was exhibited at the National Gallery on its way to an Irish museum. He was sent a letter signed by one hundred or so English artists and collectors which said: "From the moment your painting was hung amid the masterpieces of the past, we had the pleasure of observing that one of our contemporaries has immediately taken his rightful place among the great masters of the European tradition."

ALBERT ANDRÉ, *RENOIR*

To watch this crystal globe just sent from heaven to associate with me. While these clouds and this sombre drizzling weather shut all in, we two draw nearer and know one another. The gathering in of the clouds with the last rush and dying breath of the wind, and then the regular dripping of twigs and leaves the country o'er, the impression of inward comfort and sociableness, the drenched stubble and trees that drop beads on you as you pass, their dim outline seen through the rain on all sides drooping in sympathy with yourself. These are my undisputed territory.

HENRY DAVID THOREAU, *JOURNALS*

Gustave Caillebotte
Rue de Paris, Wet Weather
1877

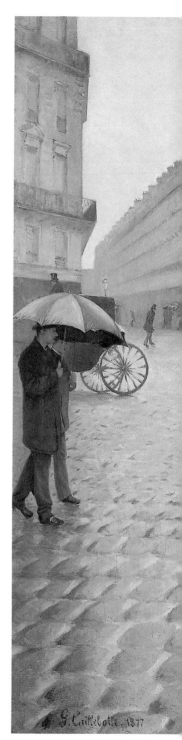

WINTER

Then sleep the seasons, full of might;
While slowly swells the pod,
And rounds the peach, and in the night
The mushroom bursts the sod.

The winter comes; the frozen rut
Is bound with silver bars;
The white drift heaps against the hut;
And night is pierced with stars.

COVENTRY PATMORE, *WINTER*

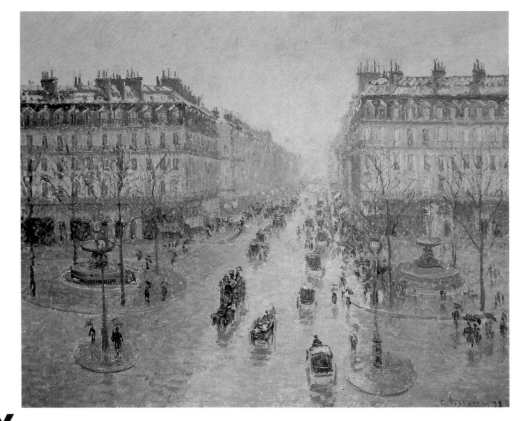

Camille Pissarro

Left: *Avenue de l'Opera, Paris*
1898

Opposite: *Boulevard Montmartre, Night Effect* (detail)
1897

You see the three great diverging streets which dazzle you like so many luminous abysses; Rue de la Paix, all gleaming with gold and jewels, at the end of which the Colonne Vendôme rises against the starry sky; the Avenue de l'Opéra inundated with electric light; Rue Quatre Septembre shining with its thousand gas jets, and seven continuous lines of carriages issuing from the two Boulevards and five streets, crossing each other rapidly on the square, and a crowd coming and going under a shower of rosy and whitest light diffused from the great ground-glass globes, which produce the effect of wreaths and garlands of full moons, colouring the trees, high buildings and the multitude with the weird and mysterious reflections of the final scene in a fairy ballet.

EDMONDO DE AMICUS, *STUDIES OF PARIS*

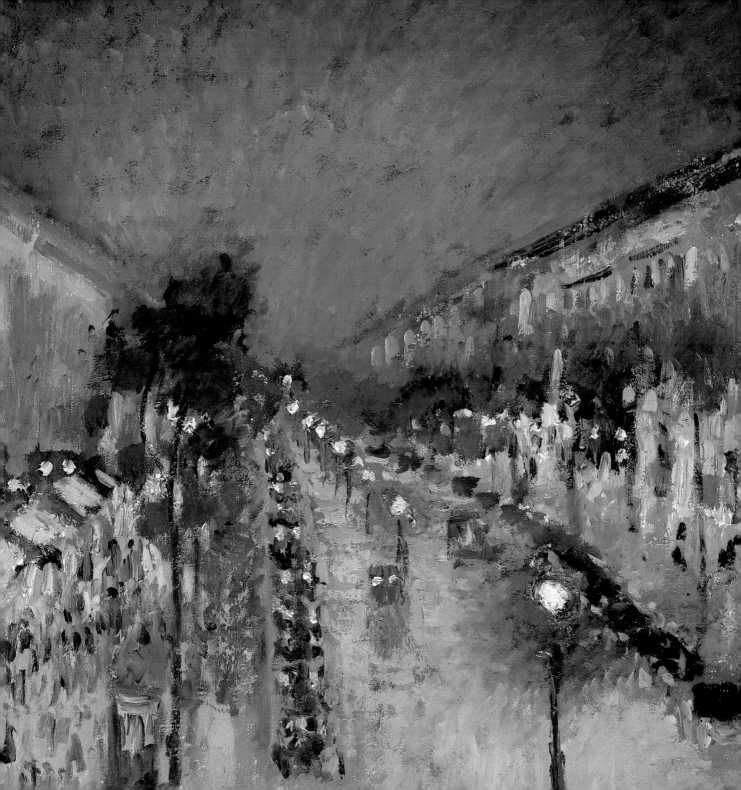

Sandviken, via Christiania, 26 February 1895

Dear friend, a brief note just to assure you of my fate, so that you don't suppose that I have died from the cold.

I am filled with wonder by all that I see in this marvellous country. I have been on four-day outings by sleigh, in the mountains, over fjords, on the lakes; it's fantastic! With all this accomplished with the average temperature being 25°[F] at noon, still I have never suffered, to the great amazement of the Norwegians, who are more sensitive to the cold than I am! I am in very good health, in spite of the atrocious food, but very annoyed at not being able to paint all that I see! I did not know where to look and became so discouraged that on several occasions I almost took the train back home.

At last I have found a suitable location in which to settle, and here I am at work, though it has only been for a few days. I have started eight paintings, and if I am not too thwarted by the weather, they will give you some impression of Norway and the area surrounding Christiania, a country less terrible than I had imagined. I would have liked to have gone farther north, but it is hardly possible in this season. However, it is terribly beautiful all the same. I was not able to see even a small bit of sea or any water whatsoever. Everything is frozen and covered with snow. One should live here for a year in order to accomplish something of value, and that is only after having seen and come to know the country. I painted today, a part of the day, in the snow, which falls endlessly. You would have laughed if you could have seen me completely white, with icicles hanging from my beard like stalactites.

Your faithful friend, Monet

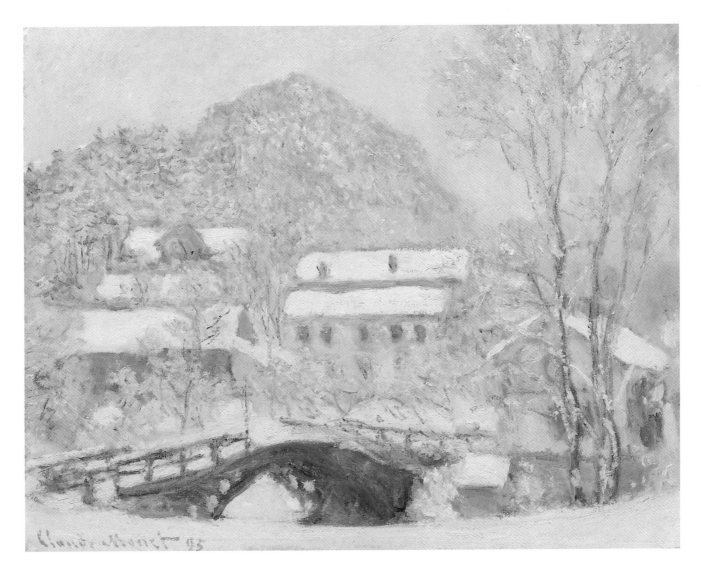

Claude Monet

Sandviken, Norway
1895

Pierre-Auguste Renoir
Snowy Landscape
(Detail) c.1875

White does not exist in nature. You admit that you have a sky above that snow. Your sky is blue. That blue must show up in the snow. In the morning there is green and yellow in the sky. These colours must also show up in the snow when you say that you painted your picture in the morning. Had you done it in the evening, red and yellow would have to appear in the snow.

PIERRE-AUGUSTE RENOIR

Announced by all the trumpets of the sky,
Arrives the snow, and, driving o'er the fields,
Seems nowhere to alight: the whited air
Hides hills and woods, the river, and the heaven,
And veils the farm-house at the garden's end.
The sled and traveller stopped, the courier's feet
Delayed, all friends shut out, the housemates sit
Around the radiant fireplace, enclosed
In a tumultuous privacy of storm.

Come see the north wind's masonry.
Out of an unseen quarry evermore
Furnished with tile, the fierce artificer
Curves his white bastions with projected roof
Round every windward stake, or tree, or door.
Speeding, the myriad-handed, his wild work
So fanciful, so savage, nought cares he
For number or proportion. Mockingly,
On coop or kennel he hangs Parian wreaths;
A swan-like form invests the hidden thorn;
Fills up the farmer's lane from wall to wall,
Maugre the farmer's sighs; and at the gate
A tapering turret overtops the work.
And when his hours are numbered, and the world
Is all his own, retiring, as he were not,
Leaves, when the sun appears, astonished Art
To mimic in slow structures, stone by stone,
Built in an age, the mad wind's night-work,
The frolic architecture of the snow.

RALPH WALDO EMERSON, THE SNOW-STORM

Announced by all the trumpets of the sky,
Arrives the snow, and, driving o'er the fields,
Seems nowhere to alight: the whited air
Hides hills and woods, the river, and the heaven,
And veils the farm-house at the garden's end.
The sled and traveller stopped, the courier's feet
Delayed, all friends shut out, the housemates sit
Around the radiant fireplace, enclosed
In a tumultuous privacy of storm.

Come see the north wind's masonry.
Out of an unseen quarry evermore
Furnished with tile, the fierce artificer
Curves his white bastions with projected roof
Round every windward stake, or tree, or door.
Speeding, the myriad-handed, his wild work
So fanciful, so savage, nought cares he
For number or proportion. Mockingly,
On coop or kennel he hangs Parian wreaths;
A swan-like form invests the hidden thorn;
Fills up the farmer's lane from wall to wall,
Maugre the farmer's sighs; and at the gate
A tapering turret overtops the work.
And when his hours are numbered, and the world
Is all his own, retiring, as he were not,
Leaves, when the sun appears, astonished Art
To mimic in slow structures, stone by stone,
Built in an age, the mad wind's night-work,
The frolic architecture of the snow.

RALPH WALDO EMERSON, THE SNOW-STORM

Pierre-Auguste Renoir
Snowy Landscape
(Detail) c.1875

White does not exist in nature. You admit that you have a sky above that snow. Your sky is blue. That blue must show up in the snow. In the morning there is green and yellow in the sky. These colours must also show up in the snow when you say that you painted your picture in the morning. Had you done it in the evening, red and yellow would have to appear in the snow.

PIERRE-AUGUSTE RENOIR

In the bleak mid-winter
 Frosty wind made moan,
Earth stood hard as iron,
 Water like a stone;
Snow had fallen, snow on snow,
 Snow on snow,
In the bleak mid-winter
 Long ago.

CHRISTINA ROSSETTI, *A CHRISTMAS CAROL*

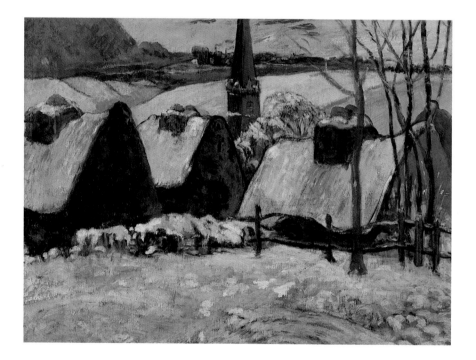

Paul Gauguin

Breton Village in the Snow
c.1894

Henri Le Sidaner

Le Trianon under Snow
1905

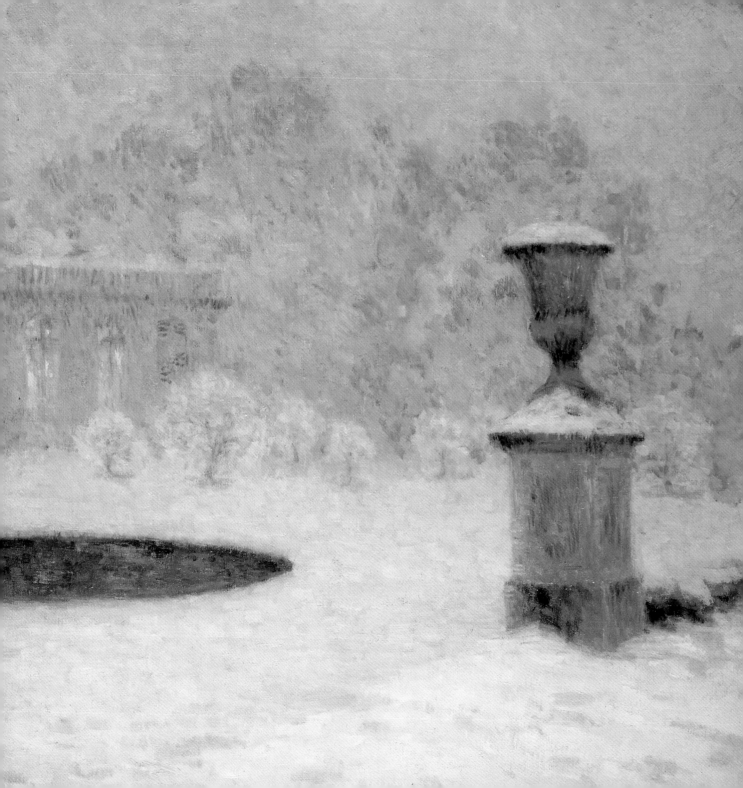

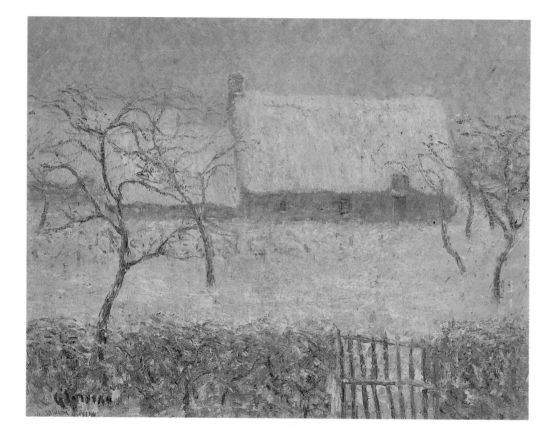

Gustav Loiseau
Paysage d'Hiver
1909

Through the hushed air the whitening shower descends,
At first thin-wavering; till at last the flakes
Fall broad and wide and fast, dimming the day
With a continual flow. The cherished fields
Put on their winter-robe of purest white.
'Tis brightness all; save where the new snow melts
Along the mazy current.

JAMES THOMSON, *THE SEASONS: WINTER*

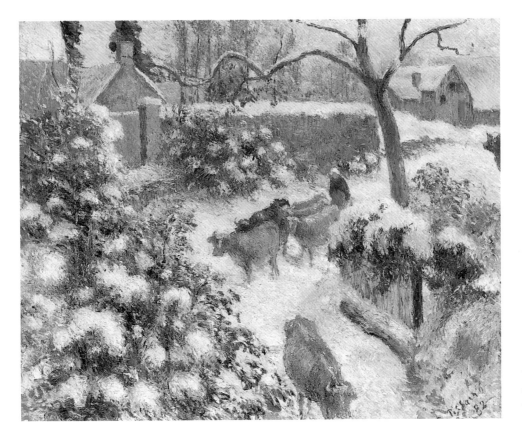

Camille Pissarro

*Effet de neige à
Montfoucault*
1882

Claude Monet

The Thaw on the Seine
1880

At five in the morning, I was woken up by a frightful noise, like the rumbling of thunder...on top of this frightening noise came cries from Lavacourt; very quickly I was at the windows and despite considerable obscurity saw white masses hurtling about; this time it was the debacle, the real thing.

<small>ALICE HOSCHEDÉ, LETTER TO ERNEST HOSCHEDÉ</small>

My only desire is an intimate fusion with nature, and the only fate I wish is to have worked and lived in harmony with her laws.

<small>CLAUDE MONET, LETTER TO GUSTAVE GEFFROY</small>

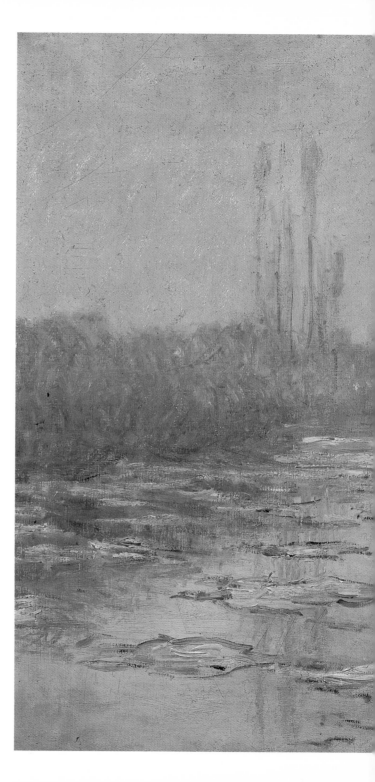

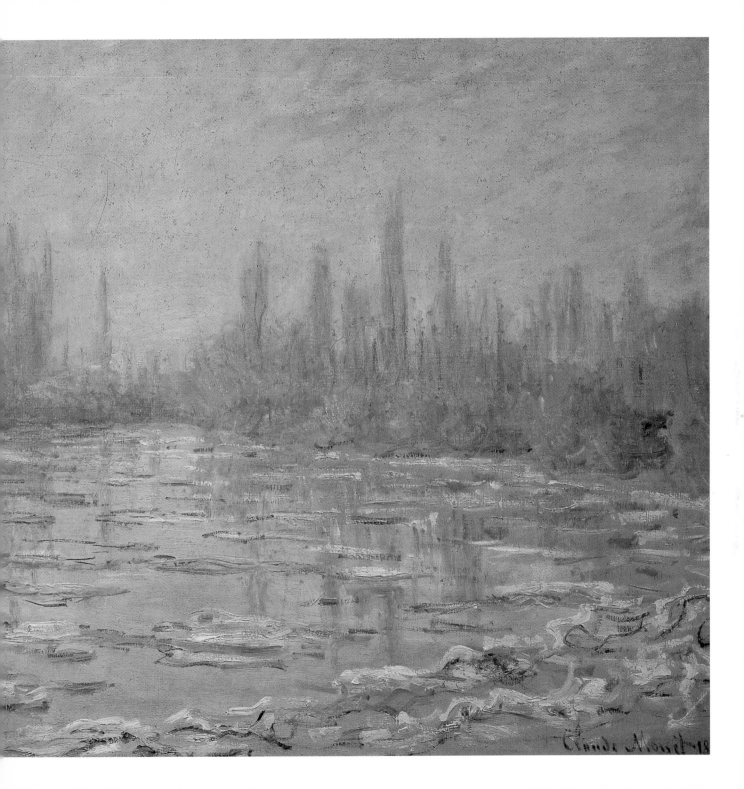